Artistic Change at St-Denis

PRINCETON ESSAYS ON THE ARTS

for a complete list of books
in this series,
see page 117.

Artistic Change at St-Denis

ABBOT SUGER'S PROGRAM AND
THE EARLY TWELFTH-CENTURY
CONTROVERSY OVER ART

CONRAD RUDOLPH

PRINCETON UNIVERSITY PRESS
PRINCETON, NEW JERSEY

Copyright © 1990 by Princeton University Press
Published by Princeton University Press,
41 William Street,
Princeton, New Jersey 08540
In the United Kingdom:
Princeton University Press, Oxford

Library of Congress Cataloging-in-Publication Data
Rudolph, Conrad, 1951–
Artistic change at St-Denis : Abbot Suger's program
and the early twelfth-century controversy over art /
Conrad Rudolph.
p. cm.—(Princeton essays on the arts ; 17)
Includes bibliographical references.
ISBN 0-691-04068-0
1. Art, Gothic—France—Saint-Denis. 2. Art,
French—France—Saint-Denis. 3. Church decoration
and ornament—France—Saint-Denis. 4. Suger,
Abbot of Saint Denis, 1081–1151—Contributions in
Gothic art. 5. Eglise abbatiale de Saint-Denis. 6. Saint-
Denis (France)—Buildings, structures, etc. I. Title.
II. Series.
N6851.S29R8 1990
726'.5'0944362—dc20 89-10606 CIP

This book has been composed in Linotron Palatino

Princeton University Press books are printed on
acid-free paper, and meet the guidelines for
permanence and durability of the Committee on
Production Guidelines for Book Longevity of the
Council on Library Resources

Printed in the United States of America
by Princeton University Press
Princeton, New Jersey
1 3 5 7 9 10 8 6 4 2

TO ANNA KATHARINA

CONTENTS

PREFACE

The art program worked out at the monastery of St-Denis under the direction of Abbot Suger during the years 1122 to 1151 is, in some ways, unequaled in the entire Middle Ages as a subject of study for the history of art. Not only do we have one of the great pivotal monuments of the twelfth-century artistic change that was to lead to Gothic—in its architecture, architectural sculpture, stained glass, and use of typology in art—but we also have the most thorough account of any such program ever written in the medieval period: in short, the most complete body of evidence for the emergence of a distinct artistic style in the premodern West.

Granted that Suger directed this work in consultation with an architectural master, the abbot has emerged as perhaps the preeminent representative of artistic creativity of the Middle Ages. But what, exactly, brought about this burst of artistic creativity? What were the issues that led to the formation of Suger's program? Why are the meanings of the major artworks of one of the best documented of all medieval art programs so obscure? Such questions are not easy to answer, and this study can only do so within certain limits. It proposes to investigate some of the social forces that were of concern to Suger and that were referred to by him in his writings. Formal, structural, or aesthetic aspects of St-Denis are avoided since Suger's writings indicate that they were not of primary importance to him in his account of the origins of the program. This is not to say that these areas are not of importance to art historians today, only that the evidence suggests that they were secondary to Suger. Also, this is a study of the relation between the early twelfth-century controversy over art and the artistic change that took place at St-Denis, not of the controversy itself. It is concerned with the meaning of the art of St-Denis and of Hugh of St-Victor's role in its origins only in light of their relation to artistic change there, not for their own sake. Certain aspects of the economic issues raised in this study are taken up in my forth-

coming book, *The Things of Greater Importance: Bernard of Clairvaux's Apologia and the Medieval Attitude toward Art*, and are not repeated here. And no political interpretation of the relation between the art of St-Denis and the French monarchy will be adequate until more is known of the identities of the statue-columns of the west end. Finally, the concepts put forth in this study are presented as specific to St-Denis, and so valid only for the time and place indicated, although they may be applicable to other times and places.

I would like to thank Stephen Gardner, Stephen Gersh, Kathryn Horste, Wolfgang Kemp, Peter Klein, Martin Powers, Dan Selden, Joseph Wawrykow, Karl Werckmeister, and John Williams for their support and/or critical readings of this text, both of which were of great help to me. Additional thanks goes to Dan Selden and Dan Sheerin for advice on certain problems with the translations, although any shortcomings are my own.

I would also like to thank the Department of Fine Arts at the University of Pittsburgh and the Andrew W. Mellon Foundation for the Mellon Postdoctoral Research Fellowship (1986–1987) which enabled me to undertake the greater part of this study; and the Getty Center for the History of Art and the Humanities for the Postdoctoral Fellowship in residence (1987–1988) during which this work was completed.

University of Notre Dame
July 1988

Artistic Change at St-Denis

INTRODUCTION

Not long after securing French secular and ecclesiastical support in his schismatic struggle with Anacletus II for the papacy, Innocent II paid an official visit to the monastery of St-Denis, just outside of Paris, in order to participate in the liturgical celebrations of Holy Week (1131). Here, at a lavish ceremony "offered to God and to man," Abbot Suger received the pontiff with "odes of exultation," later joining him in the abbey church to celebrate Easter mass, a "basilica glowing red with crowns of gold, and glittering with the splendor of precious gems and pearls a hundred times greater than silver and gold."[1] St-Denis was at this time the most prestigious and wealthy monastery in the French realm, a monastery which was closely identified with the French monarchy and whose patron saint was in fact the patron saint of the monarchy itself. Its abbot, Suger, was perhaps the second most influential ecclesiastical figure in the kingdom.[2] Yet, with the possible exception of some Sugerian modifiers, there was really nothing very special about either the account or the event that it describes. On the contrary, it was the unofficial visit that Innocent made only a few weeks later to the monastery of the man who was actually the most influential ecclesiastical figure in France that was of importance—important then in the recognition that it gave to a certain attitude toward art, and also now in the attempt to understand some of the forces at play in the gradual formation of Suger's art program at St-Denis, an art program which was pivotal in the artistic change that has come to be called Gothic.

Shortly after being received at St-Denis with that ceremony offered to God and to man, Innocent traveled considerably out of his way to make a personal, not official, visit to the monastery of Bernard of Clairvaux, the man to whom more than any other he most directly owed the general support north of the Alps for his claim to the papacy. There, at Clairvaux, "a place of awe and of enormous solitude"[3] and also a place to which many of the best of Eu-

3

rope's new breed of monks were flocking, Innocent was met by a
community

> not decked out in purple and linen, and not rushing to meet
> him with gilded gospels, but by a ragged collection of men
> carrying a rough cross. . . . The bishops wept, the high pon-
> tiff himself wept, and all were amazed at the gravity of that
> community in which, in such solemn joy, the eyes of all, fixed
> on the ground, wandered nowhere in curiosity. . . . The Ro-
> man saw nothing in that church which he might desire, no
> liturgical furnishings disturbed their attention there, they saw
> nothing in the oratory but bare walls.[4]

The important thing about this was not that a monastery should
be devoid of artworks and that its church should have bare walls.
Certainly, there were many poor monasteries, and even ones
which had willingly chosen a similar state in regard to art.[5] The
important thing was that the stated policy of artistic asceticism of
a distinctive monastic faction should have received, or could be
claimed to have received, what amounted to unofficial papal ap-
proval and recognition at a time when that faction was challenging
certain of the entrenched customs of mainstream monasticism, in-
cluding its attitude toward art. Indeed, the artistic asceticism of the
Cistercian Order and the legislation that so severely restricted its
use of liturgical art and virtually proscribed monumental sculpture
and painting from its monasteries had been famous for some time,
and was even seen by contemporaries as one of the fundamental
characteristics of the Cistercian way of life.[6] Even more to the
point, this was the current prestige position in regard to art among
many of those within mainstream monasticism who considered
themselves to belong to the new monastic reform movement.

This, then, was the atmosphere in which Suger initiated his art
program, an atmosphere in which non-mainstream reformers in-
fluenced many members of mainstream monasticism in a direction
away from the traditional attitude toward art. This was the atmos-
phere in which Suger, a man generally agreed to be essentially
unoriginal and unclear in matters of expression, assumed a posi-
tion of responsiblity for perhaps the most dramatic conceptual
change in Western medieval art through the means of probably the

most original and highly organized art program to date. In architectural terms it involved a change from the typically heavy, barrel-vaulted churches of the Romanesque—whose wall was relatively restrainedly pierced for light in order to avoid weakening the structurally necessary continuity of the wall mass—to the physically and visually lighter skeletal system of Gothic with its ribbed groin vault and stronger, more adaptable pointed arch. This combination permitted a much greater opening up of the surface area of the wall for light, a metamorphosis for which the operation of Pseudo-Dionysian light mysticism has been credited by modern scholars. The atmosphere and the change have both long been recognized. But scholars have been less quick to come to grips with the reasons for that change.

Erwin Panofsky never addressed the change formally, being less concerned with the reasons why Suger's art program should have taken the conceptual and artistic shape that it did than with the reasons why Suger chose to write his two main accounts of the art of that program. Recognizing the essentially antagonistic positions of Suger and Bernard, Panofsky believed that the two had come to a political understanding by 1127, and that as a result of this understanding Suger was free to do whatever he wished in regard to art without fear of public criticism from Bernard. Nevertheless, Panofsky felt that Suger had for the most part directed his writings against the Cistercians.[7] But he thought that Suger also had members of his own monastery in mind when he wrote—both "sophisticated" members who felt that Suger's taste was somewhat less than refined and traditionally minded ones who opposed his tearing down of parts of the old church which were considered especially sacred.[8] In the process, Panofsky accepted at face value Suger's traditional justifications of communal assent, of the manifestation of divine approbation through various miracles connected with the construction, of professed concern to retain as much as possible of the old structure, and of the necessity of rebuilding as a result of crowding and of the ruined state of the old building.[9]

As to Suger's application of Pseudo-Dionysian light mysticism, Panofsky also took this at face value, at one point describing Su-

ger's use of this mystical theology as the latter's most potent weapon against Bernard's criticisms of certain aspects of monastic art.[10] In particular, Panofsky saw the references to light in certain inscriptions written by Suger for his new church as evidence that Suger was claiming an anagogical function for his art—as will be explained later. But in the end, it was largely on institutional and personal grounds that Panofsky explained Suger's use of this obscure and novel system of thought: it simply was the teaching of the abbey's patron saint and it confirmed Suger's own personal tendencies.[11] Ultimately, it was on the level of personal psychology—the will to self-perpetuation, overcompensation for his humble birth, a complete self-identification with the monastery of St-Denis as a result of his being given over as a child, an ambition driven by a less than average stature—that Panofsky sought the means with which to understand the impetus for Suger's artistic change and his writings which deal with that change.[12]

If Panofsky tended to see the motivations behind Suger's work and writings in psychological terms, Otto von Simson readily integrated them into the larger picture. Based on Panofsky's study of Suger's use of Pseudo-Dionysian light mysticism and an undeveloped theory of A. K. Porter's which suggested that Suger had created a "national style" of art in the service of French royal politics, von Simson saw Suger's architectural undertaking as the creation of the image of heaven on the one hand, and the implementation of a political master plan in support of the crown on the other.[13]

Far from being a defense against Cistercian artistic attacks, von Simson felt that Suger's program possibly reflects the ideas of Bernard, that it was in any case compatible with Bernard's aesthetic views, and even that "Bernard's insistence" that art function to lead the viewer to the transcendental source of all beauty appealed profoundly to Suger.[14] Indeed, he believed that Bernard would probably have agreed that a monastery like St-Denis had to make concessions to the lay pilgrims who were so actively sought there.[15] In fact, according to von Simson, both Suger and Bernard opposed Romanesque/Cluniac art—Bernard being impelled to reject the architectural forms of the past, and Suger's innovations being no less than the artistic expression of Bernard's *Apologia*.[16]

Finally, von Simson noted that although St-Denis was the pro-
totype of the Gothic cathedrals, all of the major elements of Gothic
architecture were already in existence by the time Suger began his
rebuilding of that church.[17] It was not so much the technical com-
ponents of Gothic that defined its appearance at this moment as it
was the conceptual components and the relation between the tech-
nical and the conceptual, the whole being the expression of some
new religious experience. On the purely artistic level, he saw this
effected through the use of light in conjunction with the stained
glass window, and the latter's replacement of the brightly colored
mural of the Romanesque. Such a process had the result, he felt,
that imagery now occupied a less conspicuous place in the reli-
gious experience, and that the aesthetics and metaphysical poten-
tial of architecture now predominated. The Gothic window, he
felt, was a demonstration of Pseudo-Dionysian light mysticism,
and Gothic architecture might never have come about if it were not
for the Pseudo-Dionysian writings.[18]

THE HISTORICAL SITUATION

When Suger was installed as abbot on March 12, 1122, the general opinion as to just what constituted the cutting edge of reform monasticism was already in the process of change. The old traditional Benedictine reform movement which had rebuilt monasticism after the dissolution of the Carolingian Empire had been so successful that it had fallen into a "crisis of prosperity."[1] Traditional monasticism had actually become too successful as an institution to maintain complete credibility as a way of life that espoused simplicity, rejection of the world, and voluntary poverty. Its primary source of income, prayer services and burial for the dead (called the Cult of the Dead in this study), had encouraged a tendency toward accretions in the Divine Office or *opus Dei* which were seen as contrary to the original simplicity of the monastic life. The large land donations made for these services led to the monastic administration of secular properties and the assumption of parochial duties, and so to a high degree of external social involvement. Another major and growing source of income, the pilgrimage (Cult of Relics), also encouraged more internal social involvement through pastoral care than was believed to be in the original spirit of the Benedictine Rule, and served to dilute monastic seclusion as well. The general wealth that resulted was seen as encouraging an undesirable luxury in everyday life and liturgy.[2]

A new monastic reform movement sought to reject all this, its principal representative being the Cistercian Order, and the Cistercian Order's principal representative being Bernard of Clairvaux.[3] The Cistercians observed a stripped-down *opus Dei*. And, although practice may not have paralleled theory, they theoretically renounced burial of the dead to the public; refused to own secular churches, serfs, villages, and so on; built their monasteries in generally secluded locations and denied entry to women; and regulated matters pertaining to luxury through mandatory legislation.[4] The Cistercian economy was based on an advanced system

of agriculture in contrast to that of traditional monasticism which, although agriculturally based as well, was also dependent on the *opus Dei* and the pilgrimage in many of its wealthier monasteries.[5]

The reaction of traditional monasticism to this new movement was mixed. Some actively opposed the tenets of this reform, challenging its supporters publicly. Others chose to abandon the customs of traditional monasticism, either transferring to Cistercian monasteries individually or, in some cases, as institutions. But many within the old monasticism were not unsympathetic, and some even wished to reform themselves in matters concerning the major points of criticism.[6] The controversy, then, was not simply one of one side against the other, but rather one of issues with extremists on either side and, within traditional monasticism, an apparently large middle ground which was looking for middle ground solutions to those issues.

At St-Denis, the question of reform had become current enough for Suger to consider it in his and the monastery's interests to put into effect a now only partially known number of changes referred to by Bernard in a letter to Suger of 1127 as all but complete.[7] The tone of Bernard's letter implies that he saw himself as the impetus to those changes. But the limited scope of what he described as his only objection to Suger's abbacy at St-Denis (the luxury of Suger's retinue) and his characterization of Suger's changes as "unexpected" suggest that although something Bernard had done may have been the stimulus to Suger's changes, those changes were essentially identified and initiated by Suger himself.[8] The changes are of interest because they are indicative of Suger's position on the contemporary issue of reform, and also because they perhaps tell us a little about the relation of Bernard to Suger's changes.

The changes as described by Bernard seem to have largely applied to a few circumscribed areas, most notably those of Suger's retinue, the opening up of what apparently were normally restricted parts of the monastery to curious laymen, and some irregularity concerning the cloister, probably an objection to political and commercial business being conducted there.[9] At least as far as the present state of knowledge goes, Suger's changes involved nothing concerning the simplification of the liturgy and the rejection of the burial of nonmonastic dead, and nothing aside from

9

that which has already been mentioned concerning social involvement and luxury. Far from it. Suger increased rather than decreased the already long liturgy, being an enthusiastic defender of liturgical elaboration; he tried to convert the practice of royal burial at St-Denis from a customary practice into a right of the monastery; he continued to acquire secular properties and churches; he encouraged rather than discouraged pilgrims; and the existing enactments suggest than he tended to improve the quality of the monks' meals.[10] In other words, very little concerning the form of monastic life proper at St-Denis seems to have been affected according to Bernard's account.

The important thing, however, was that Bernard himself—who was seen by contemporaries as both a saint and a hypocrite, even at the same time[11]—was willing to accept the changes as enough, despite the fact that they had almost nothing in common with the more fundamental reforms of liturgy and discipline being advanced at that time by certain traditional Benedictine monasteries which had the open support of Bernard.[12] Bernard had his reasons for publicly acknowledging Suger's changes and in the process claiming credit for them: he had forced or had given the appearance of forcing the obeisance of one of the most visible leaders of traditional monasticism at a time when it was regrouping—rhetorically at least—after the early sustained offensive of the new reform,[13] and had openly demanded Suger's considerable influence in the removal of a powerful opponent of Bernard at court as the final mark of completion of Suger's "reform."[14] Suger for his part had achieved a modus vivendi which permitted him to continue to function politically without significant opposition from Bernard, and at the same time to establish a relation of some kind with middle-ground reform.[15] It is interesting that the changes put into effect by Suger were described by Suger himself as a "reform," but by Bernard as only "an unexpected change."[16] Given the circumstances, it seems that Suger very much wanted his changes to appear to be a reform. That is, he wanted to give the appearance of being somehow associated with the mainstream reform movement, even describing his changes as the most important accomplishment of his abbacy.[17] To be sure, Suger was not a supporter of the new reform, nor was he actually a supporter of the moder-

ate reform within traditional monasticism, as his own actions show. But with the minimal approval of Bernard of Clairvaux he could at least claim a connection.

If this connection was desirable for St-Denis' position within the political configuration given the recent ascendancy of Bernard and his party, it was necessary for the status of St-Denis given the contemporaneity of reform. Reform was contemporary, and a premium was put on contemporaneity in the rapidly changing secular and ecclesiastical society of twelfth-century France. Contemporaneity for a monastic institution at this time implied, among other things, not only the traditional respectability in matters of morals and discipline expected of a frontline monastery, but also the profession of new spiritual standards which in part meant moving beyond what some saw as an emphasis on ritualism by the old monasticism. It was in this sense that contemporaneity was an important element of public respect and of self-respect for a monastery. So if Suger's actual position in regard to religious expression and the monastic life did not really belong to that reform, he at least wished to cloak himself in its contemporaneity—and it was this same cloaking of an inherently traditional position in the appearance of contemporaneity that characterizes his attempt to find a middle-ground solution to the issue of monastic art.

THE ARTISTIC SITUATION

When Suger was installed as abbot, the general opinion as to the propriety of monastic art was in the same process of change, or at least of review, as the rest of monastic life. The years of Suger's career as a common monk and the tenure of his abbacy comprise one of the great periods of Western artistic production and perhaps the greatest of Western medieval art: the period of the growth of monumental sculpture and painting, of advanced Romanesque architecture, of the stained glass window, of the establishment of the use of typology in art, of the origins of Gothic architecture and sculpture. It was one of the great periods of artistic expansion, and yet, it was also the period of the greatest opposition to art in the West to date. Many issues were raised concerning the use and misuse of art within the monastery. But Suger was selective in his response. He chose to address only a few of the issues through his artworks and writings; and so it will be only those aspects of the controversy with which I will be concerned here.

Monasticism had been responsible for much of this explosion of artistic production, and yet there was no specifically monastic basis for art in anything approaching the theoretical. Rather, for the most part monastic art typically differed from secular religious art only in specifics. That is, the monk had theoretically set himself apart from the world, but generally his art was not similarly theoretically set apart.[1] Instead, monasticism based its use of art on the same justifications of doctrine and tradition employed by the secular Church.[2] Doctrinally, the Church sanctioned the use of art to educate the illiterate in spiritual matters on the basis of two letters of Gregory the Great to Bishop Serenus of Marseille, and the literal application of this doctrine was never publicly questioned by anyone except overt heretics during this period.[3] Nor was the cultural tradition of the use of art to honor God and the saints through commemoration and decoration ever seriously questioned—a tra-

dition so strong that it almost had the force of doctrine. This tradition was typically justified on the basis of Old Testament precedent—it made no difference that it was Old Testament law that forbade imagery—but really was such a strong part of the pre-Christian culture at the time of the widespread adoption of Christianity that Christianity had been obliged to come to terms with it.[4]

There were never any doctrinal restrictions on specific forms of art in the West after the official establishment of Christianity, but there were some restrictions imposed by tradition. The most pervasive was that concerning art's potential for idolatry among a recently converted, and later a spiritually uneducated, audience. The most comprehensive expression of this tradition, which was a constant throughout the history of medieval Christianity, is that of Bernard of Angers (written after 1020) who spoke of general attitudes, while making reference to specific forms of art. According to Bernard of Angers, Church tradition rejected the use of sculpture in the depiction of any image except that of the crucifix, although he admitted that this tradition was not followed everywhere. Based on a fear of idolatry, he drew a strong distinction between the image of the crucified Christ and images of the saints, finding the image-reliquary particularly susceptible to idolatry. But while sculpture in general may not have been permitted according to this tradition, he noted that the use of mural painting for the depiction of saints was considered to be perfectly acceptable.[5]

Aside from sculpture, there was also a tradition within monasticism that allowed for the rejection or the restricted use of precious materials in liturgical art. Imagery was not in question here, but rather the more specifically monastic concerns of luxury as opposed to the suppression of the senses, materialism as opposed to spirituality, and/or cost as opposed to simplicity and voluntary poverty. Although by no means widespread, this tradition was a historical constant and received a certain amount of attention from non-Cistercian reform monasticism in the late eleventh and early twelfth centuries.[6]

So, there had been a functioning post-Carolingian and noniconoclastic tradition of opposition to art before the Cistercians. But it was not until Bernard of Clairvaux and the Cistercian institution-

alization of artistic asceticism that the latter became so powerful an issue. It was the written, mandatory legislation of the Cistercians, probably enacted sometime from 1115 to 1119 under the direct sponsorship of Bernard, that captured the imagination of Suger's contemporaries in its promise of unchanging artistic asceticism.[7] The artistic counterpart to the liturgical accretion, the elaboration of the liturgy through an increase of liturgical and monumental art, was also open to characterization as luxury, and so was doubly challenged in the process of external criticism and internal debate in the monastic controversy of the early twelfth century.

Cistercian legislation approached the problem comprehensively. Cistercian Statute 10 limited the use of silk to the stole and maniple, prohibited more than one color for the chasuble, and proscribed the use of gold, silver, and jewels in all liturgical art with the exception of the chalice and fistula which could be of gilded silver.[8] Statute 20 virtually eliminated the use of monumental sculpture and painting in the monastery, allowing only a painted wooden crucifix. Between these two statutes, liturgical art and monumental art were all but banned from Cistercian monasteries. It is no coincidence that these were the artistic mainstays of the two primary sources of nondomanial income of traditional monasticism associated with social involvement: the Cult of the Dead and the Cult of Relics—both economic means which the Cistercians theoretically rejected.

But the Cistercians were careful to stay within the minimal standards proposed by tradition and doctrine. Concerning luxury in material, the limited use of silk for the stole and maniple had become by that time standard; the use of gilded silver (as opposed to wood, horn, and so on) for vessels which came into direct contact with the Eucharist had been promulgated as the minimum for some time by liturgical reformers. As to imagery, the Cistercians were careful to reject it on the grounds of spiritual distraction and not on that of its teaching function: the allowance of painted crucifixes was meant to confirm the Cistercian orthodox position. But while Statute 10 implied a rejection of liturgical art for such traditional reasons as luxury and materialism, Statute 20 explicitly re-

jected monumental art for reasons not yet really a part of stated tradition. While art had been objected to as a spiritual distraction before, this had been done only rarely and in the vaguest possible way. In its proscription of monumental art as a spiritual distraction, the Cistercian reform movement was also indirectly questioning the spirituality of traditional monasticism. And while the Cistercians completely accepted art within the limits of a literal interpretation of its doctrinal basis, they accepted it only within those limits. Since the primary doctrinal justification of art within the church was to teach the illiterate, and since the instruction of the illiterate public increasingly better taken care of by the canons regular and secular clergy was no longer seen as the function of the literate monk—put in contemporary polemical terms, since "the monk does not have the function of a teacher, but rather of a mourner,"[9]—there was no longer any doctrinal justification for art within the monastic church. Quite the opposite—it could be seen by some as indicative of a retrogressive form of monasticism. So without denying either the doctrine of art to educate the illiterate or the tradition of art for the honor of God and the saints, Cistercian monasticism had in effect rejected both in regard to monasticism.

Three years after Suger was installed, Bernard published his famous treatise criticizing certain aspects of traditional monasticism, the *Apologia ad Guillelmum* (probably summer–autumn 1125).[10] This is not the place to go into the question of to whom the *Apologia* was addressed. It is enough for the purposes of this study to say that it was nominally addressed to William of St-Thierry, the abbot of a traditional Benedictine monastery, and we may assume that Bernard did not have St-Denis specifically in mind when he wrote his criticisms of monastic art.[11] Since the *Apologia* is the most comprehensive statement on art from the Middle Ages, and since Suger's response to the controversy over monastic art was so selective, many of the issues raised by Bernard in the *Apologia* are also beyond the scope of this study. However, while not pretending to present an analysis of the *Apologia* itself, it is possible to identify within that treatise a number of serious challenges to the traditional attitude toward the use of art within the monastery as they

pertain to the writings and artworks of Suger. These challenges more or less fall into the four categories of ritualism, materialism, the dilution of monastic seclusion, and art as a spiritual distraction.

1. *Ritualism.* Although he knew that he could not hope to overcome monasticism's willing acceptance of the tradition of art for the honor of God and the saints in any fundamental way, Bernard nevertheless opened his criticism of monastic art with just this issue. Professing a grudging acceptance of the excessive size of some monastic churches on the basis of this tradition, he went on to characterize such religious expression as ritualistic through reference to its Old Testament precedent. But it was not the venerable precedents of the divine instructions to Moses for the tabernacle (Exod. 25–27, 30–31) or of the divine approbation of Solomon's temple (esp. 3 Kings 9:1–9; 2 Chron. 7:11–22) which traditional proponents cited as justifications that Bernard brought to mind. Instead, he turned the justification of Old Testament precedent upon itself by choosing to refer to the "ancient rite of the Jews," a rite whose ritualism he saw as the antithesis of monasticism's own spirituality. Thus the question as he saw it was not one of illegitimacy versus legitimacy, but rather of ritualism versus spirituality.

2. *Materialism.* Bernard's repeated references to the precious materials from which the various artworks he mentions are made and the great cost involved in making them are aimed at the same vulnerable point: the materialism involved in luxurious artworks and its corresponding denial of or threat to monastic spirituality. This is presented on both the practical and the moral level. Devoting most of his attention to the liturgical artwork, Bernard notes that such expense is not appropriate to simplicity and voluntary poverty, nor is its appeal to the senses compatible with spirituality.

3. *Dilution of monastic seclusion.* One of the elements of traditional monasticism's social involvement to which the reform movement objected was the dilution of monastic seclusion. And one of the ways that art could act to encourage this was the attraction of laymen to the monastery. Although this theme barely surfaces in Bernard's criticism of the art of those monks who "have been mingled with the gentiles" (*Apologia* 28), it implicitly underlies much of his criticism.

4. *Art as a spiritual distraction.* The most significant of Bernard's criticisms for Suger's art program was that of the use of art to educate the spiritually illiterate. While Church doctrine sanctioned the use of the material and so nonspiritual medium of art to stimulate the unspiritual, its presence in a monastery, a place of spiritual men, could only act to retard spiritual growth, distracting them from higher things, and so was unjustified. Even worse was that art for which no doctrinal or devotional function could be claimed. Singling it out in perhaps the best known passage of this treatise, Bernard specifically condemned the proliferation of images of monsters, animals, and men engaged in worldly pursuits as a distraction from spiritual reading and meditation.

While secular and secular Church opinions were certainly factors in the controversy over monastic art, monasticism was complex and sophisticated enough to provide its own audience for the debate. As near as can be told from the meager written sources, most of the opposition to art after the widespread acceptance of Christianity and before Bernard and the Cistercians had been based on traditional objections such as luxury, materialism, and so on. Such objections could be fairly easily sidestepped by means of the traditional justifications of art for the honor of God and the saints, and art to educate the illiterate. But after the enactment of the Cistercian legislation on art and especially after the *Apologia*, real pressures were at play that gave new force to traditional objections to the use of art by monasticism. And while the Cistercians and Bernard did still employ these traditional objections, their opposition to art now also took on a deeper significance such as a questioning of the economic impetus to the role of art in the Cult of the Dead and the Cult of Relics. And so it was that when the traditional Benedictine abbots of the province of Reims at the reform chapters of 1131 and 1132 publicly defended their liturgical and artistic reforms to the papal legate, Cardinal Matthew of Albano, those indefinite artistic reforms were formulated as part of a general statement defending their overall reform of the *opus Dei*.[12] Given the nature of this new questioning and the status of those raising the questions, they were questions which only insignificant monasteries could afford to ignore entirely. And so the sensation

that this controversy now created. And so the need for Suger to respond on a higher level than was previously customary. But before I take up Suger's response to this situation, it is first necessary to discuss the gradual character of the development of Suger's art program and justifications.

3

THE GRADUAL DEVELOPMENT
OF SUGER'S PROGRAM
AND JUSTIFICATIONS

The appeal of some sort of restrictive attitude toward art at this time was not limited to the Cistercians alone. If it were, Suger would not have had to concern himself with it. An attraction to a restrictive attitude toward art was at least gaining the appearance of acceptance among certain segments of traditional Benedictine monasticism, as the apparent consensus concerning art among the traditional but reforming Benedictine abbots of the province of Reims suggests. Yet artistic asceticism was only one response to the question of the relation of art to monasticism. Later concern for the issues raised in this controversy shows that there was also a desire for a middle-ground solution to the polarization of the traditional position and artistic asceticism. Suger's efforts in this direction as expressed in both his artworks and his writings are the most thorough attempt at a middle-ground solution extant from this controversy. Although his main concern was the justification of his own art program at St-Denis, justification on the particular level of physical need was not enough. In order for it to be able to be claimed as acceptable by reform elements, whether outside or inside the monastery, it was necessary for him also—indeed, primarily—to justify his program on the intellectual/spiritual level.

To begin with, both the physical development of Suger's art program and its conceptual expression in his writings came about only gradually. This element of gradual development is important in understanding the role of St-Denis in twelfth-century artistic change, and in understanding some of the forces at play in that change. As to the physical development of Suger's art program, there is no reason not to accept Suger's own statement that each major phase of the rebuilding of the abbey church led to the idea

of undertaking the next.[1] That is, the repair and repainting of the nave of the old Carolingian church, which Suger had conceived of before 1106 at the latest and which was begun sometime from 1122 to 1125, suggested, by 1125, the idea to undertake some sort of work on the west end.[2] The work on the west end, whose goal according to the original plan of 1125 was "to renovate and decorate the entrance of the church," was expanded sometime before early 1137 to an "augmentation of the new and great building of the church"—something which is significantly different in that its goal was to provide more space for pilgrims on the great feast days, as opposed to the maintenance of things as they then stood.[3] The rebuilding and extension of the west end led Suger to the rebuilding of the east end.[4] That is, Suger's first project was conceived of before Cistercian legislation had helped to begin to increase the force of the issue of the monastic use of art, and it was begun before the *Apologia* brought this issue to the forefront and before Suger's "reform" of the abbey. The project of the west end was conceived of at this time, but in all probability was fundamentally revised and only in full production sometime before 1137,[5] a good time after the major statements against the traditional position on monastic art had been written. The east end, Suger's greatest project and a work intimately connected with his theories on art, followed without any hesitation.[6]

The conceptual expression of this art program as embodied in Suger's writings, too, came about only gradually, although they should not be thought of as directly paralleling the physical development. The major sources for Suger's theories on the function of art in the monastery are the *Ordinatio*, *De Consecratione*, and *De Administratione*.[7] None of the titles is original.[8] The *Ordinatio* is simply one of many *ordinationes* or enactments; *De Consecratione* is not specifically on the consecration of the west and east ends; and *De Administratione* is not actually on Suger's administration of St-Denis. In regard to the dates of these important documents, Panofsky showed that the *Ordinatio* was enacted sometime between the foundation of the east end on July 14, 1140, which it mentions, and January 22, 1142, the date of the death of one of the witnesses.[9] With *De Consecratione*, he followed the parameters suggested by Albert Lecoy, according to which that work was written

after the consecration of the east end on June 11, 1144, which is mentioned in it, and before *De Administratione* which mentions *De Consecratione*.[10] As to *De Administratione*, Panofsky followed Otto Cartellieri's argument which associated its origin with the request made in the twenty-third year of Suger's abbacy (Mar. 12, 1144–March 11, 1145) by the community of St-Denis mentioned in its opening passage, believing that it was begun sometime after *De Consecratione*. Cartellieri and Panofsky felt that it was not completed or at least subject to corrections until the end of 1148 or the beginning of 1149 because it mentions the death of Evrard de Breteuil, which occurred during the Second Crusade—apparently an error for the end of 1147 or the beginning of 1148.[11]

However, it seems that *De Administratione* was more likely written sometime from around January 1150 to around September of the same year. First, the state of construction of the new church is so much more advanced in *De Administratione* than in *De Consecratione* that the former must have been written a significant length of time after the latter. *De Consecratione* was written after the consecration on June 11, 1144, of the east end and discusses financing for the continuation of the east and west ends, but does not mention any work, or any intention to work, on the transepts and nave, nor does it mention the actual resumption of work on the towers of the west end. *De Administratione*, in contrast, discusses all of these. In fact, it even mentions the completion of one of the towers. After having finished the west end proper, Suger felt that the drain on the time and resources required for the conclusion of the towers "in their upper parts" was so great that it threatened his new plans for the reconstruction of the east end. When the east end was finished, he resumed work on the western towers. Yet he soon postponed work on the towers once again, now fearing that it would interfere with his latest plans to rebuild the transepts and nave during his lifetime. Nevertheless, work had progressed far enough in the meantime for one of the towers to have been completed.[12]

As to work on the transepts and nave, enough had been accomplished by the time of *De Administratione* for Suger to speak of it as something which would—he thought—inevitably be finished.[13] Given the fact that one of Suger's main objections to continuing

21

work on the towers was the time involved, it seems reasonable enough to propose a period of two or so years for the one completed tower and the work mentioned on the transepts and nave: a block of time which would require a *terminus post quem* of the period of Suger's regency, February 18, 1147 (the date he was chosen), to November 1149.

However, a number of other facts combine to suggest that *De Administratione* was not written during the regency. The period of the regency was one of great turmoil and real danger. It was a time when Suger himself was threatened with the charge of treason, and when he was forced to deal personally with no less than the attempted takeover of the kingdom by the king's brother, Robert of Dreux. But more than a period in which it would have been unlikely for Suger to write, it seems that it was one in which he in fact did not write, for *De Administratione* mentions too many events—both integral and incidental—which occurred after Suger had been chosen regent. For example, *De Administratione* records in its important chapter 32—a chapter which programmatically continues the justifications of chapter 30—the consecration of Suger's Great Cross by Pope Eugenius III, an act which took place on April 20, 1147.[14] And as already mentioned, Cartellieri noticed that *De Administratione* briefly refers to the death of Evrard de Breteuil on crusade, something which probably happened on January 8, 1148.[15]

But more importantly, in comparing his undertaking at St-Denis to Hagia Sophia in Constantinople, Suger notes in one of the more significant chapters of the book that he had spoken with certain people who had been to Jerusalem, specifying that these were among those "to whom the treasures of Constantinople and the ornaments of Hagia Sophia had been accessible." When the latter assured Suger that his treasures were superior to those of the Greeks, he writes that he thought that the travelers might have said this inadvertently because

> those marvels of which we had heard before might have been put away, as a matter of precaution, for fear of the Franks, lest through the rash rapacity of a stupid few the partisans of the Greeks and Latins, called upon the scene, might suddenly

with the communal request originally made for what was to become *De Consecratione*.[19]

This does not, however, account for why *De Administratione* should have been written in the first place. Since the two writings are not actually complementary, a good part of the answer may be sought in the differences between *De Administratione* and *De Consecratione*, and to a lesser degree between *De Consecratione* and the *Ordinatio*. To take only the major themes, the *Ordinatio* of July 15, 1140, to January 21, 1142, was more than a simple legal decree. Although Suger made no attempt in it to present his art program as a whole, this decree enacted in the presence of the bishops of the French realm is the first known public justification made by him of that program—a decree which was conceived by Suger in a literary style (as opposed to legal) worthy enough to have had half of its section on art included by him almost verbatim in *De Consecratione*. It refers to the justifications of art for the honor of God and the saints, the reciprocal element in honoring God and the saints with art, the relation between craftsmanship and material, and the factor of communal agreement in the commissioning of artworks.[20]

But all of these are mentioned in only the most formulaic way; so much so that it is as if their mere mention were enough and no further discussion were necessary. With *De Consecratione* of sometime soon after June 11, 1144, however, the idea of justifying the art program of St-Denis is taken up energetically, if superficially. The justifications of art for the honor of God and the saints, reciprocity, the relation between craftsmanship and material, communal agreement, and now the active encouragement of the art program on the part of God and the saints and the justification of art as a spiritual aid, all practically permeate the account.[21] And yet with the exception of the discussion of Suger's theory of reciprocity, their presentation is a thoroughly superficial one, one which deals with the general question of the religious use of art in an unpenetrating way and which does not take up the monastic element at all.[22] Also, while giving a fair account of the rebuilding of the abbey church, the figural aspect of the program is detailed in only the most tentative way.

De Administratione of 1150, on the contrary, takes up the previ-

be moved to sedition and warlike hostilities. . . . Thus it could happen that the treasures which are visible here, deposited in safety, amount to more than those which had been visible there, left [on view] under conditions unsafe on account of disorders.[16]

It seems certain that what Suger is describing here is the reception of the Franks at Constantinople during the Second Crusade. When the Frankish army under King Louis VII reached Constantinople on October 4, 1147, almost all of the crusaders were refused entry into the city—something which Odo of Deuil, who was present as the chaplain of the king, said was quite understandable given the disorders caused by the mob which in part made up that army. Only the king and a limited number of his court were allowed to see the palaces and churches of the city where the treasures of Constantinople and the ornaments of Hagia Sophia were indeed made accessible to them.[17] The king and his court later reached Jerusalem, and returned to France in November 1149, after which there must have been a brief period of bureaucratic transition. While Suger undoubtedly talked to many travelers to Jerusalem during his life, it seems that it is to the return of those like Odo of Deuil, Suger's successor as abbot of St-Denis, that he refers in this particular passage. As Suger fell fatally ill during the last "four months or more" of his life, probably in September 1150, and as his illness was so severe that in the last weeks he knew his end was at hand,[18] it seems probable that most of the writing of De Administratione took place sometime from around January 1150 to around September 1150. This would certainly account for the rapid pace at the end and for the reference to "after our demise" in the opening passage. Consequently, it would be probable that De Consecratione was begun and finished soon after the consecration of June 11, 1144 (the twenty-third year of Suger's abbacy), with which it concludes and before any significant construction had been completed elsewhere. And so it seems that the immediate outcome of the general request of the community between June 1144 and March 1145 was not De Administratione, but rather De Consecratione. The new presentation of Suger's art program in De Administratione only followed five or six years later, now justified

23

ous issues—art for the honor of God and the saints, reciprocity, craftsmanship and material, communality, the encouragement of the art program on the part of God and the saints—generally treating them more forcefully, and at the same time offering a far more complete presentation of the art program even though its passage on art is almost exactly the same length as *De Consecratione*.[23] To this was added the justification of the Old Testament precedent for religious art. But most importantly, *De Administratione* takes up the issue of art as a spiritual aid on a relatively theoretically advanced level, if not articulated in an advanced way, doing so both in general terms and through certain of the individual artworks themselves.[24]

And so we see that the pattern of change between the three documents is one of ever increasing justification of Suger's art program. While in no way comprehensive, the *Ordinatio* shows the incipient concern of Suger to justify the program publicly, even if only formulaically. *De Consecratione* went beyond this in its conscious first step toward a comprehensive justification of the program, but remained far from complete and essentially superficial. Suger apparently became dissatisfied with this presentation after a number of years and undertook a complete reformulation of how he wanted his program to be perceived. The result was *De Administratione* with its relatively advanced traditional justifications of religious art in general, and nontraditional justifications of monastic art in particular.[25] But it is just this gradual intensification that indicates Suger's inherently conventional position in regard to art. Indeed, the gradual introduction of these nontraditional justifications suggests that they do not represent Suger's primary personal feelings toward art at all. And as soon as one moves away from writings specifically justifying the art program at St-Denis—that is, as soon as there is no overt reason for Suger to be justificative and so when he has let his artistic guard down—one finds the same simple delight in splendor and luxury that underlies all of his writings on art, even the most justificative.[26]

4

SUGER'S RESPONSE:
TRADITIONAL JUSTIFICATIONS

The traditional criticisms current in the general controversy over certain aspects of the monastic use of art evoked a traditional response from Suger. Avoiding most of the hard questions raised by Bernard in the *Apologia*, Suger chose instead to respond selectively. As these justifications are well known and had little direct impact on the innovations of the program at St-Denis, they may be dealt with briefly. Although for the sake of clairity I tend to treat them as if they are distinct concepts, many of them overlap considerably.

The two main counterparts to the charge of ritualism in religious art are art for the honor of God and its justifications, and the theory of reciprocity which was so fervently expressed by Suger.

Suger's justification of art for the honor of God and the saints was thoroughly traditional. Artworks simply are made for the honor of God. Suger recognized the claims of his opponents that "a saintly mind, a pure heart, a faithful intention" are enough to honor God in that circumstance which most requires honor, the celebration of the Eucharist. But to Suger it was a question of "all inner purity and all outward splendor"—and all outward splendor demands "every costlier or costliest thing."[1]

While art for the honor of God and the saints was one of the preeminent justifications of religious art in its own right, it itself was also justified. The most formal of these justifications was that of the Old Testament precedent of religious art, in particular the divine instructions given to Moses concerning the tabernacle and the divine approbation given to Solomon in the construction and furnishing of the temple.[2] As found in Suger's writings, the Old Testament precedent is part of one of the major justificative passages. But it was not directly to the Old Testament precedent of Moses or Solomon that Suger chose to refer, as had Matthew of

Albano quite unsuccessfully to the abbots of the province of Reims just a few years before. Rather he chose to refer to it indirectly through the New Testament authority of Paul. In a passage using the imagery of the liturgical art of the tabernacle,[3] Paul rejected the ritualistic purification of the outer life he found in the Old Law as inferior to the spiritual purification of the inner life he found in the New. Suger used the passage, not without a certain twist of logic, in order to claim that if such luxurious sacred vessels were proper for the ritualistic, how much more proper were they for the spiritual.[4] Through this reference to Paul, Suger makes a pretense of recognizing the ritualism of the Old Testament practice while at the same time building on it as precedent.[5] In other words, he claimed to reject the ritualism while embracing the ritual—truly a middle-ground position.

To show that there was no doubt but that this use of art was indeed what God and the saints wanted and was not a figment of the mind of man, Suger, like so many others before him, offered proof through the listing of various signs of celestial encouragement. Where he differs from those before him is in his almost constant reference to this encouragement. And not only does he recount such signs as the miraculous pulling of a heavy column by the weak and the protection of the unfinished vaults of the east end by divine intervention,[6] but he also sees the simple provision of funding and materials in the same light. Indeed, such signs as the availability of a new quarry, of unexpected wooden beams, of large amounts of gold and jewels were such clear statements of divine intention that it would have been an offense to ignore them.[7] However, the recounting of building miracle-type stories is restricted to the earlier *De Consecratione,* and with the exception of one story about the divine provision of gold and gems—specifically meant to embarrass Bernard and the Cistercians[8]—so are the accounts of the divine provision of materials. With *De Administratione,* the emphasis is now on the role of divine inspiration or the hand of God in all the major undertakings of the art program. Now it is no longer merely a question of God's "help" or even of his "counsel and aid." Now it is "under the inspiration of God" and "under the inspiration of the divine will" that the program came about.[9]

One of Suger's strongest justifications of art—the theory of the role of art in the reciprocal relationship between the celestial and the terrestrial—was related to the charges of both ritualism and materialism. It is little more than a Christianization of the old pagan concept of *do ut des*, I give so that you may give. Suger openly recognized that what mattered above all was a purified mind, in the same way that he did with the justification of art for the honor of God. But in the same passage that he stated this, the opening chapter of *De Consecratione*, he went on to explain that it is necessary to proclaim God's generosity, for not to do so would be to risk a diminution of that generosity. This is essentially the returning to God of a part of what God has already given; and one of the best ways of doing this is through art, particularly through the most precious materials possible.[10] The stone used from the new quarry was seen as firstfruits, and the writing of *De Consecratione* and even the consecration of the church were seen as reciprocal acts in themselves.[11] In fact, the reciprocal nature of the entire art program was announced in two of the most important inscriptions in the church, the dedicational inscriptions of the west end and of the altar frontal of the tomb of St Dionysius.[12] But most importantly for our purposes, Suger felt that he was justified by faith concerning this. Returning again to the authority of Paul for this and for his belief that the more one gave the more one might expect to receive in return, he once more avoided, at least in his own mind, the charges of ritualism and now also of materialism.[13]

Aside from the use of Paul, Suger attempted to defend his position against charges of materialism on the practical, aesthetic, and moral levels. On the practical level, which is related to signs of encouragement provided by God and to reciprocity, he pointed out that precious materials were not financially prohibitive but on the contrary were made available by God, who seemed to him to be the immediate cause of their availability; they were made available by men, who made donations either as simple donors or as the dealers of the materials themselves; and they were made available by no less than Bernard of Clairvaux himself, who seems to have been the abbot of the unnamed Cistercian monastery of *De Administratione* which was instrumental in providing a vast quan-

tity of jewels for the Great Cross when Suger was unable to obtain them elsewhere.[14]

On the aesthetic level, Suger referred to the quality of the craftsmanship of various works of art in the *Ordinatio* and *De Consecratione*, but only in terms of straightforward praise. It is in the later *De Administratione* that he tried to justify the overt materialism of his program in a discussion of his renovation of the high altar by making a pretense of dismissing the question of its lavish materialism through his direct quotation of an expression of Ovid's, "The craftsmanship surpassed the material," in reference to the high altar.[15] However, such a traditional defense based on classical literary authority carried little weight with the explicitly anti-Ovidian reformers.[16] Ironically, Suger discredited his own claim to this aesthetic defense in a less direct literary dependence, but one which was conceptually more important in that it was the predominant justificative inscription of the program—being the introductory inscription on the artistic centerpiece of the west end, the gilded doors. Here he uncomprehendingly boasted of the great cost of the doors both in the inscription itself and in his text, not to mention that the Ovidian aesthetics mixed unconvincingly with the Pseudo-Dionysian spirituality with which they were joined.[17]

But, in the end, an aesthetic defense was of little use against a moral attack. And so on the moral level Suger was compelled to claim the traditional defenses of personal simplicity and voluntary poverty. Such is the function of William of St-Denis' account of Peter the Venerable's reaction to Suger's art program. William first conjured up the image of Bernard testifying to Suger's spiritual credentials, then adroitly shifted to Peter the Venerable. William described how after having just seen *eum opera et structuras*, Suger's artworks and new additions to the abbey church, Peter was taken to Suger's humble cell, where he emitted the desired—not reaction but *sententia*—"This man condemns us all, who builds not for himself but for God alone."[18] Despite such protestations, these were traditional justifications and had little impact on the form of the art of St-Denis. It was Suger's nontraditional moral justifications of materialism and art as a spiritual distraction that were to provide a defense which apparently found recognition among his

contemporaries, and that were to have such a profound effect on artistic change at St-Denis. But these will be taken up later.

Traditional justifications of art were not particularly successful against their nontraditional challenges in the early twelfth-century atmosphere of change, as Matthew of Albano may have observed. Suger avoided the most difficult of these challenges such as art as opposed to the care of the poor and, aside from the issue of art as a spiritual distraction, only tangentially touched upon certain others such as those directed against artistic excess in the *opus Dei* and the Cult of Relics—again, primarily in *De Administratione*. His efforts along these lines are included in this section since they are traditional responses and had little impact on the innovations of St-Denis. As to challenges to artistic excess in the *opus Dei*, Suger did not directly take it up, but did refer often to the role of Dagobert and Charles the Bald, and once to Charlemagne, in the artistic history of the abbey—Dagobert and Charlemagne being seen by contemporaries as authorities for the emphasis on the Cult of the Dead in the traditional Benedictine form of the *opus Dei*.[19] And unable to effectively defend the part played by art and especially pilgrimage art in the attraction of laymen to the monastery, and so in the unnecessary dilution of monastic seclusion, Suger apparently could do little more than emphasize the seclusion of the St Romanus chapel in the west end and its propriety for divine rites.[20] Although not formulated thoroughly enough to take on the force of justifications, these two efforts do indicate an awareness of the issues involved.

Finally, there are a few other justifications or claims related to the justificative process that pertain not to the general theoretical level of justification, but rather to the particular level of physical need or institutional claims. While the necessity of rebuilding because of overcrowding seems to have been legitimate at St-Denis, Suger's reference to the same story of fainting women in all three of his writings carries a tone of awareness of the practice of rebuilding when need was not the determining factor.[21] For example, the legitimate claim of the lack of choir space at Cluny was used to overexpand the new abbey church of Cluny III.[22] And, in fact, the claim of the overcrowding of the monks was considered an important enough one for rebuilding for it to have found its

way into no less than the *Life of Bernard of Clairvaux* itself in the account of the construction of Clairvaux II—undoubtedly legitimately, but equally as undoubtedly put forth in an overtly defensive manner by Bernard through his biographer.[23] And so all the more reason for Suger to have been somewhat defensive, since the crowding at St-Denis was the result not of an overcrowding of monks, but rather the result of an overcrowding of laymen—in other words, the dilution of monastic seclusion. Along these lines, Suger was careful to give the appearance of communal agreement in the commissioning of artworks, although this was by no means necessarily the case.[24] And lastly, supraregional claims were made by the time of *De Administratione* in regard to the procurement of artists and materials from outside the area of immediate availability, and in regard to artistic rivals; these claims being implicitly intertwined with the justifications of art for the honor of God and Suger's theory of reciprocity, and indicative of his essentially traditional attitude toward art.[25]

Art for the honor of God, a deft handling of the Old Testament precedent of religious art, signs of celestial encouragement, reciprocity—Suger had presented a good argument along traditional justificative lines. But a traditional justification of art was not enough, even among certain circles of the Benedictines. In order to maintain a claim to contemporaneity, something more was needed. Without at least some kind of suitable defense against the nontraditional challenges to the monastic use of art, Suger's position could be no more acceptable among frontline monasticism than the stridently traditional position of Matthew of Albano which had been rejected by elements of Benedictine monasticism during the formative period of Suger's art program at St-Denis. However, Suger's unsystematic approach and the hesitation which is a part of the gradual intensification of justification in his writings suggest that systemization and sophisticated justification—where they appear in his artworks and writings—were not something that came from Suger himself.

5

SUGER AND HUGH OF ST-VICTOR

Originality, clarity, geometry, the use of complex exegesis, and the appearance of Pseudo-Dionysian light mysticism are among those characteristics for which the art program at St-Denis is best known. And yet the writings of Suger are marked by a lack of originality, by the virtual absence of a readily identifiable system of organization, of any discussion of geometry, of any substantial theological argument, and of any comprehensive presentation of Pseudo-Dionysian thought. It is no coincidence that it is on precisely these points that Hugh of St-Victor, the contemporary Parisian theologian, excelled.

The contradiction between Suger's writings and his art program is unmistakable. Scholars have noticed that the imagery of the west central portal (fig. 1) is more sophisticated than Suger's use of words, and that there is a general absence of a readily identifiable organization in his writings such as that found in the portal. Occasionally and generally coincidentally, they have contrasted what they see as Suger's absence of organization, innovation, style, and knowledge of theology with Hugh of St-Victor's abilities in these same areas. In short, they have been unanimous in their assessment of the striking gap between the concepts which are involved in the program as they appear in his writings and those same concepts as they appear in the artworks themselves.[1]

It has been suggested several times that Suger's attempt to integrate the mystical theology of Dionysius the Pseudo-Areopagite into his art program was one that was mediated by some secondary source. Panofsky suggested the ninth-century commentary of John Scotus Erigena on Pseudo-Dionysius's *The Celestial Hierarchy* as an intermediary between the difficult writings of Pseudo-Dionysius and Suger. Von Simson went further in trying to relate the artistic change at St-Denis more closely to its contemporary environment, including Hugh of St-Victor. However, his brief references to Hugh are almost entirely undeveloped and, as Grover

Zinn has pointed out, the relation between Hugh and Suger can be more closely defined.[2] According to Zinn, Hugh's theology of the works of creation and restoration is discernible in the bronze doors of the west end.[3] However, while the general case for Hugh's participation is reasonable, too little is known about the very common passion and ascension cycles of these particular doors to distinguish them from any other passion and ascension cycles, and so to firmly tie down the attribution of Hugh's thought to the program at St-Denis.[4] Zinn does, though, further suggest that the language in Suger's writings on art is not directly dependent on either Pseudo-Dionysius or Erigena. And he also suggests "in passing" the possibility that a certain schematic drawing made by Hugh for one of his theological works may contribute to a better understanding of the west central tympanum. It can, I believe, be shown that Hugh's participation was in all likelihood far more direct than has been previously believed, and far more fundamental to the art program than just the area of Pseudo-Dionysian light mysticism alone.

To begin with, Suger needed help. His writings suggest that he was inherently traditional in the area of art. They give every indication that his primary goal was not to incorporate the philosophy of Pseudo-Dionysius into religious art, but to maintain claims of contemporaneity amid the controversy over monastic life while at the same time pursuing a program of artistic luxury. In the area of art this meant justifying his art program according to contemporary standards, standards which demanded at least a degree of nontraditional justification. Anything else was secondary. If Suger was not able to do this, then he had to get someone who could. According to Suger's biographer and personal secretary, William of St-Denis, "In him flourished not only a natural felicity of memory, but also the highest art of understanding what had to be done and taking heed to such a degree that he held in readiness whatever exceptional things he either had heard said or had said himself at one time or another for the place and time [that they would be needed]."[5] In the same way that Suger sought out the greatest artistic experts he could find from "diverse regions," so he sought out the greatest intellectual expert. And just as he went to great lengths in securing those artists not only for their skill but also for

the supraregional claim to artistic authority their work embodied, so he sought out Hugh of St-Victor not only for his intellectual powers but also for the supraregional claim that his intellectual authority embodied.[6]

Indeed, not long after his arrival around 1115 to 1118 at St-Victor, the famous Parisian abbey of regular canons, Hugh established himself as one of the leading theologians of Europe, considered by his contemporaries to be unsurpassed in divine knowledge.[7] He is believed to have begun teaching at St-Victor around 1125, the same time that Suger is known to have committed himself to renovating the west end, and was elected head of the school of St-Victor in 1133.[8] St-Victor was greatly favored by King Louis VI, having been formally founded by him, built by him, and chosen by him as the place of burial for two of his children.[9] As a principal counselor to Louis VI and Louis VII (who was also considered a great benefactor of St-Victor), Suger cooperated with the house and even helped increase its holdings.[10] And St-Victor, near the site of what was to become the Sorbonne, was only a short walk from the royal palace on the Ile de la Cité where Suger spent so much time as advisor to the king. The importance and proximity of both men in a town, not city, of 2500 to 3000 people precludes that they did not have contact with each other.

It was only logical that Suger, as probably the only monastic author of his time who did not compose a single theological treatise,[11] should have turned to Hugh for theological advice for his complex program. Although Hugh might at times claim that he was only a synthesizer of the Fathers, his originality was recognized by his contemporaries.[12] He was a master of organization and clarity, and a first-rate geometrician, having composed a treatise on geometry entitled *Practica Geometriae*.[13] But it was exegesis, including allegorical exegesis—important early artistic examples of which are found in the high altar reliefs, windows, and Great Cross of St-Denis—on which Hugh was truly an authority, being one of the greatest of all medieval exegetes, and seen as having revitalized the field.[14] And if it was logical that Suger should have turned to Hugh for advice on theology and exegesis, it was even more logical that he should have turned to Hugh for advice on Pseudo-Dionysian thought in view of the fact that Hugh had writ-

ten a commentary on *The Celestial Hierarchy*, a work believed by many then to be by the patron saint of St-Denis, and believed by many now to be the source of a theory of light mysticism responsible for Suger's development of the stained glass window. In regard to Suger's art program at St-Denis, it seems to be no coincidence that Hugh's commentary, *In Hierarchiam Coelestem*, was written before the 1125 decision to renovate, revised after 1137, and dedicated to Louis VII probably during the construction of the west end—both of whose lateral portals make explicit hagiographical or literary references to Pseudo-Dionysius.[15]

But something more than simple logic went into Suger's solicitation of the advice of Hugh. If traditional monasticism felt it now had to justify its use of religious art, it was largely as a result of pressures applied by the new reform movement. Previously in this study I have mentioned only the monastic element of the new reform movement. But this movement was two-pronged, the other component being that of the regular canons. While the Cistercians and others like them sought to reform the monastic wing of the Church, the regular canons hoped to complete Church reform by raising the standards of the clergy of the secular Church. One of the means through which they hoped to achieve this was what they saw as the reimposition of the communal life of the early Church among the clergy. While remaining clergy, they often lived a life similar in many ways to that of the new monastic orders, and often had close ties to them. And this seems to be at least part of the reasoning behind Suger's solicitation of Hugh.

The house of St-Victor is generally considered to have been originally organized in 1108 by William of Champeaux, the teacher and opponent of Abelard. It received its foundation charter and strong royal support in 1113 from Louis VI, who built the abbey, and it continued to have close royal ties.[16] After William was made bishop of Châlons-sur-Marne in the same year, he became the strongest early supporter of Bernard, maintaining regular personal contact and spreading the fame of Bernard throughout "the province of Reims and all of France."[17] Not only were visits regularly exchanged between the bishop and Bernard and his monks, but the bishop—who continued to teach at St-Victor—also invited canons from St-Victor to Châlons, where some of them decided to

enter Bernard's monastery.[18] By the time William died and was buried at Clairvaux in 1121, relations were well established between St-Victor and Bernard; and when the rules of the Victorines were formalized and written, Bernard played an influential part. Bernard maintained contacts with St-Victor, and gave it support in its conflict with the cathedral chapter of Paris.[19] Hugh himself was of great interest to the Cistercian thinkers of the time, apparently being recommended by Abbot Maurice of Rievaulx to a man who was to become the Benedictine abbot of Westminster, and cited by Aelred of Rievaulx around the time that Suger was rebuilding the east end.[20] To be sure, Hugh and Bernard corresponded on doctrinal issues, and the two are believed to have mutually influenced each other so much that there has been a certain amount of confusion in the past over the authorship of their writings.[21]

And so we see that there was a strategic value to Hugh over and above his authority as a theologian per se. He was acceptable to the reform movement, and was, indeed, a part of it. But there were areas in which Hugh's and Bernard's views—or perhaps practice is a better word—differed, such as in the area of art.[22] Hugh's writings are full of references to art: straightforward references (including to Vitruvius), discussions of the symbolism of certain artworks (most notably column symbolism and the related symbolism of church dedication, possibly something that influenced Suger in the dedication of the west end), the use of artistic metaphors (for example, the repeated reference to God as an artist), and the employment of a very complex miniature as an integral part of one of his religious writings.[23] In all likelihood a relatively accomplished amateur artist himself, Hugh accepted the use of art as a spiritual aid and used it in his own writings in conjunction with the reading of spiritual texts.[24]

Hugh's qualifications, availabilty, acceptability, and interest in art seem to be beyond question. But evidence of his direct participation in the program at St-Denis is more elusive. This is because of the general nature both of much of the iconography of the program and of much of Hugh's writings. But if one focuses on those parts of the program and of Hugh's writings which are not of a general nature, then perhaps the demonstration of a concordance

between certain uncommon aspects of both may indicate the high degree to which Hugh participated in the conceptual aspect of Suger's artistic undertakings at St-Denis.

One of the most obscure elements of Suger's program is the unusual iconography of the last judgment sculptures which were fixed to the west central portal (see fig. 1).[25] Christ sits enthroned in judgment, with only the lower part of his body encompassed in the mandorla which usually surrounds the entire body. He sits in front of the cross, his arms outstretched before its arms, but unnailed and holding two scrolls. Although the present inscriptions on the scrolls from Matthew 25:34 and 41 were carved in the nineteenth century, it is believed that this was done on the basis of repeated repaintings of the original medieval inscriptions.[26] This is very probable in view of the specific iconography of the portal and its underlying basis in the Gospel of Matthew, especially chapter 25. It is assumed then that the original inscriptions quoted Matthew 25:34 and 41, reading on Christ's right, "Come, you who have been blessed by my Father," and on Christ's left, "Depart from me, you who have been cursed." In the first archivolt of four, immediately above the tympanum and along the central axis, Christ receives two souls in the form of nudes brought to him by two angels. In the two outermost archivolts, still along the central axis, is a composition of the Trinity: in the third archivolt is God the Father, largely concealed by the disk which he holds that contains an image of the Mystic Lamb behind whom is a cross; above him in the fourth archivolt, two angels accompany the Dove of the Holy Spirit.[27]

Much of the iconographical work of this portal has already been done by Paula Gerson.[28] According to Gerson, there is no single prototype which accounts for the sculptural program, although there are predecessors for many of the individual elements. She points out that last judgment scenes based on the Gospel of Matthew were not very popular in the twelfth century, and that the particular combination of the passion cycle which is known to have been depicted on the bronze doors and the judgment in the tympanum seems to be unique. She notes that the depiction of Christ in the half mandorla (fig. 2) is also unique, as is the alignment of Christ's upper body with the cross. As to the Trinity in

the archivolts (fig. 1), she believes that it is the first known example of a Trinity in monumental sculpture, and that its appearance in conjunction with the last judgment is even more unusual. The manner of depicting the Trinity is very uncommon, especially the appearance of the Lamb in place of an anthropomorphic Christ. In general, she points out the blending of Augustinian and Pseudo-Dionysian thought in the program, and the obscurity of its meaning. And so while much of the portal is not completely understood, the strength of its iconographical program suggests something very specific indeed was being put forth with confidence.

According to Gerson, Emile Mâle suggested that the Christ of the west central tympanum was derived from Honorius Augustodunensis's *Elucidarium*. But Gerson noted that the passage in question from Honorius, a contemporary of Suger's about whom very little is known, was itself based on a passage from Augustine's *De Trinitate* 1:13.[29] In his exposition on the Trinity, Augustine was concerned with resolving the contradiction between Matthew 25:31–46 which says that Christ will judge man at the end of time, and John 12:47–50 which indicates that he will not. Gerson explains that Augustine resolved the apparent contradiction in the Gospels by interpreting them to mean that while the saved will see Christ at the end of time in his divine nature, the damned will be unable, and so Christ must judge these according to his human nature. Thus the half-mandorla refers to the operation of the two natures of Christ in judgment. Gerson believes that the presence of the Trinity in the archivolts is related to Augustine's statement that upon entry into heaven, the just will comprehend the mystery of the Trinity; and so it represents not simply heaven but the final salvation made possible by Christ's death on the cross. God the Father holding the disk with the Lamb makes plain to man the relationship of the sacrificed Christ to the cosmos.[30] Aside from the straightforward subject of the last judgment, Gerson sees the iconography of the portal as emphasizing the salvation of man.

Gerson is quite right in her attribution of the iconography of the half-mandorla to Augustine. But the question arises, did it come directly from Augustine, or did it come through some intermedi-

ary—as is believed by some to be the case for Suger's use of Pseudo-Dionysius? Actually, it seems to have been both. Hugh of St-Victor, whose important commentary on Pseudo-Dionysius was originally written sometime before 1125 and expanded after 1137, is thought to have worked on his compendium of Christian doctrine, *De Sacramentis*, during the period from 1133 to 1137[31]—the crucial years for the determination of the imagery of the west end. So conversant with the works of Augustine and so similar in manner of thinking was Hugh that he was called *alter Augustinus*, a second Augustine.[32] Indeed, although sparing of direct quotes from the Fathers throughout much of *De Sacramentis*, the vast majority of the very end of the work, the part which deals with the end of the world and the last judgment, consists of passages either directly taken or closely paraphrased from Augustine, along with a few from Gregory the Great. It is no coincidence that that section which deals with the most central aspect of the last judgment, the Judge himself, should have been taken directly from the same passage which the Christ of the tympanum is based on, Augustine's *De Trinitate* 1:13, that from all patrology Hugh should have chosen this particular passage of Augustine's as the one most suited to convey his conception of the end of time.[33]

As Gerson noted, Augustine stated that while the good will be able to see Christ in his divine nature, the bad will be unable, and so Christ must judge them according to his human nature; and so the one half of Christ with the mandorla indicates his divine nature, and the other half his human nature. But the sources allow us to go further. Compared to Conques (fig. 3) or Autun (fig. 4), the christological and eschatological dimensions of the last judgment at St-Denis receive far greater attention. According to Augustine, Christ will participate in the last judgment according to both natures—as the Son of Man (his human nature) and as the Son of God (his divine nature): "The Son of Man will judge, yet not through human power, but rather through that in which he is the Son of God; and the Son of God will judge, yet not appearing in that form in which he is God equal to the Father, but rather in that in which he is the Son of Man."[34] Augustine also states that Christ was crucified under the form of the Son of Man, although

the Son of God participated. While this may be theologically clear, it is visually not very clear at all.

Given the overriding authority of the divine nature in this act, one might expect the mandorla to surround the upper half of Christ where those qualities which more closely approximate the divine are seated, as opposed to the lower half where the opposite is the case. However, an exposition of the last judgment itself was not a main concern of Augustine's, as it was with Hugh to whom it was a subject of importance in itself, or at St-Denis where it is the central element of the iconographical program of the entire west end. Augustine was primarily concerned with demonstrating the equality of the persons of the Trinity, and in particular with showing that the Son who was sent was not less than the Father who sent him.[35] And so in another passage in *De Sacramentis* where Hugh discusses the question of the Christology of the last judgment but where Augustine is not directly quoted, Hugh employs the logic of *De Trinitate* 1:13 but also makes it clear that in his human nature Christ only has the power to make the judgment known; it is actually in his divine nature that he has the power to judge.[36]

And so we see why the mandorla surrounds the lower half: because it cannot surround the upper half. It is necessary that the upper half represents the human nature of Christ so that the gestures through which Christ makes known his judgments may be visible to the damned as well as to the elect. The mandorla, meanwhile, neatly envelops the throne of judgment, the symbol of judicial authority. But the mandorla also surrounds the lower half for another reason, so that the upper part of Christ's body may clearly align with the cross. Just as the mandorla indicates Christ's divine nature, so the cross indicates his human nature as the instrument of his passion and in its aspect as the sign of the Son of Man (Matt. 24:30).[37]

In the same way that the eschatological inscriptions from Matthew 25:34 and 41 which are believed to have been painted on the scrolls held by Christ are so visually dominant in the portal program, so they culminate Hugh's abridged quotation of Augustine's *De Trinitate* 1:13. However, unlike Conques and Autun where judgment is shown to be in progress in the weighing of

souls, the dead clearly are still in the process of arising at Christ's feet at St-Denis. There are no scales, no souls being weighed. Christ makes no gesture of approval or of condemnation. There is no act of separation of the elect and the damned. Judgment is not specifically portrayed as being in progress. And yet in the first archivolt on Christ's right, souls are shown in three separate scenes in which they are successively enjoying the heavenly palace, being carried by an angel, and being held in the arms of Abraham.[38] Antithetically arranged in the same archivolt but on Christ's left souls suffer the torments of hell. It seems that what is being represented here are the different classes of souls on the last day. In the section immediately following that in which Hugh quoted Augustine's *De Trinitate*, he quoted another writing of Augustine's, part of his letter 205:2.14–15. This letter also discusses the last judgment, and in presenting what might be called a rudimentary classification of souls at the end of time cites John 3:18, "He who does not believe is already judged." This is one of the same biblical passages referred to by Gregory the Great in the *Moralia in Job*, a work quoted repeatedly in *De Sacramentis*, as one authority (along with a number of others found in *De Trinitate* 1:13) for a more developed classification of souls than that presented by Augustine.[39] It seems that the relation between the various passages in Hugh's text parallels their appearance in Suger's portal. It should be noted that Hugh held Gregory's writings in such high regard—the *Moralia* being one of Gregory's most important writings—that he actually ranked them as belonging to one of the three categories of the books of the New Testament, and recommended that Gregory's works be especially esteemed above all spiritual writings, considering them to be "sweet beyond the rest."[40] Gregory's classification foresees four groups of souls at the last judgment. There are two main divisions, the elect and the damned, each with two subdivisions. Among the elect are those who are judged and are saved, and those who are not judged and are saved. Among the damned are those who are judged and perish, and those who are not judged and perish. It seems that at St-Denis, the classes of those who are not judged are represented in the first archivolt, while the classes of those who are judged are at Christ's feet in the tympanum.[41] Thus the imagery in the archivolt is related to but distinct from

that in the tympanum: it is a conceptual elaboration on the main subject in the tympanum rather than a simple spilling over of imagery into the archivolts.

The idea of those who are not judged is so strongly associated with the two figures on either side of the bust of Christ—in fact, each type of unjudged flanking the group on either side—that the conclusion seems unavoidable that the two figures being blessed by Christ belong to those who are not judged but who are saved. Yet why do they break the strict symmetry of elect and damned in the first archivolt with the placement of one elect figure on Christ's left? What is the meaning of this second Christ—out of a total of three Christs (i.e., three images of the Second Person of the Trinity) in the same non-narrative program? And why is he so conspicuously related to the Christ of the last judgment immediately beneath him? The breaking of the symmetry suggests that these figures represent more than simple elect: the three lower compositions of elect get the idea across quite sufficiently. They apparently are different, and there apparently must be two of them.

The answer may be found in Hugh's theory of creation and restoration, a sapiential theory which like so much with the *alter Augustinus* is from Augustine but which is presented through and reshaped by Hugh.[42] According to Hugh, there are two "works" in which everything which has been done are contained, the works of creation (*opus conditionis*) and the works of restoration (*opus restaurationis*).[43] The works of creation are those divine events which took place during the six days of creation. The works of restoration are those divine events and sacraments which will take place during the six ages of man, from the beginning of time until the end of the world. The works of restoration, which comprise the subject matter of all Scripture, are of much greater dignity than the works of creation. Nevertheless, both are necessary to faith, without which it is impossible to please God, and which is the primary medium of relation with the divine since God can be believed in but can in no way be comprehended: one does not suffice without the other. Faith consists principally of belief in two things, the Creator and the Savior. Through the Creator, or works of nature, man is created. Through the Savior, or works of grace, man

42

is restored. However, the Creator and Savior are one, the Creator having undergone the passion along with the Savior.[44]

As I have said, the works of restoration consist of the divine events and sacraments which lead toward salvation. But according to Hugh, the restoration of man cannot be shown without first showing his fall.[45] The first persons created and the cause of the need for restoration were Adam and Eve. To be sure, it was at the moment of their expulsion from paradise that the sacraments were instituted.[46] The period of the sacraments' tenure necessitated by their fall is to last until the end of the world. At the end of the world, as described in the Acts of Pilate, Adam and Eve will be restored personally by Christ as the saints praise the redeeming power of the passion and the cross, with Christ blessing them and taking them to paradise (cf. figs. 2 and 5).[47] The Christianized Latin version of the *Vita Adae et Evae*, which had an extensive circulation in the Middle Ages, reinforces this tradition and further adds that Adam's body was to be taken care of by Michael the archangel—something of which the archivolt sculpture is reminiscent.[48] While these important sources on Adam and Eve are not concerned with the doctrine of the judged and unjudged, the two are clearly unjudged. Indeed, according to Irenaeus it is theologically necessary that Adam be saved, and when he is saved at the end of time, death will be destroyed.[49] Furthermore, whether or not the inscriptions from Matthew now carved on the scrolls held by Christ record the original medieval inscriptions word for word, according to Etienne Gilson medieval citations were typically meant as summaries intended to refer to the entire passage from which they came.[50] And whereas the carved inscription reads, "Come, you who have been blessed by my Father," the biblical text continues, "possess the kingdom which has been prepared for you since the foundation of the world." And so this composition depicts the restoration of man to his creator—of the first man to repent, the first Adam, to the second Adam who, as Apocalypse 21:6 and 22:13 proclaim, is the Alpha and the Omega, the beginning and the end.[51] Undoubltedly also meant in the higher sense of the restoration of man in general,[52] this view of the last judgment as the fulfillment of a promise is strikingly different from

Conques and Autun where the last judgment is evoked principally as a threat.

Thus the logic of the physical relation between the half-figure of Christ in the archivolt and the full-size image of Christ in the tympanum is clear: the elaborate exposition of the dual nature of Christ in the tympanum precludes that the bust of Christ is an expression of this duality; likewise, the appearance of the Mystic Lamb in the disk held by God the Father at the top of the portal precludes that it represents Christ in his aspect of the second person of the Trinity. Rather, the less important works of creation are represented by the half-figure of Christ, and the more important works of restoration by the full figure; and since the Creator and Savior are one and since the Creator underwent the passion along with the Savior, Christ the Creator and his creation are aligned with Christ the Savior and his cross.[53]

But the presence of the Trinity, which Gerson has characterized as the first known Trinity in a monumental sculptural program, has to be explained. To begin with, there are legitimately and purposefully several levels of meaning, all of which will not be discussed here. But one thing seems certain, and that is that its primary meaning must be related to the statement of last judgment in the tympanum, a relation also noted by Gerson as unusual.

The most overt relation between the Trinity and the tympanum lies in the actual process of the judgment itself. According to Augustine, the Trinity will not appear at the last judgment.[54] Hugh, however, chose to omit this passage in his abridged quotation of Augustine. And in that part of *De Sacramentis* where he loosely paraphrased *De Trinitate* 1:13—near the beginning of the part of the book which deals with the restoration of man—he explained that while Christ in his human nature may make judgments known, each judgment is pronounced by all three members of the Trinity together.[55] Therefore, the presence of the Trinity in the program is theologically necessary—necessary, that is, if one wished to attain a level of theological sophistication in regard to Christology and eschatology not present at Conques and Autun.

As to the general composition of the Trinity, the relation of the Dove of the Holy Spirit to the Father and the Son is strictly orthodox according to Western dogma. Although the iconography is not

as common as one might expect, it is in its general form an expression of the double procession of the Holy Spirit, more commonly known by its Latin formula, *filioque*. The dogma of the double procession espoused by the Western Church holds that the Holy Spirit proceeds from both the Father and the Son, rather than from the Father through the Son as believed by the Eastern Church.[56] The pairing of the Father and the Son, with the Holy Spirit somewhat removed from them, is a visual expression of this dogma.

The relation of the Father to the Son is less clear with the Father and Son forming a single unit, but with the Father being largely concealed by a disk that he holds, upon which the Mystic Lamb stands in front of a cross.[57] Indeed, concealment seems to be just the point. One of the sections of Augustine's *De Trinitate* which was not omitted by Hugh in his abridgment states that "No one will see the Father at the judgment of the living and the dead, but all will see the Son . . . when 'they will look upon him whom they have pierced.' "[58] He whom they have pierced is Jesus, through whom, Hugh says in his commentary on Pseudo-Dionysius, we have access to the Father who generated Jesus. It is through Christ's human nature that one comes to a greater awareness of his divine nature, and through Christ's divine nature that one is led to the Father—and so to both the Son and the Father who are one.[59] Or, as Hugh goes on to explain as another mode of access to the Father through the Son: "Jesus is the wisdom of the Father, and wisdom itself revealed the Father, and wisdom itself went forth from the Father, with the Father continuing in concealment: the Father remained invisible, and his wisdom was made visible so that it leads one to the invisible Father. And when [wisdom] was made visible it did not cease from being invisible, since it came from where it was not [visible]." Christ's human nature—whose central act is his sacrificial death—is nowhere better expressed than in his death, the sacrificial character of which is portrayed by the Lamb, a symbol for the sacrificial death of the Son offered by the Father for the restoration of man, a work of restoration whose sacrament in the Eucharist is among those on which salvation principally depends and from which all sanctification comes.[60] And so Christ is portrayed as the Lamb standing in front of a cross—he whom they have pierced—with the Father and Son

depicted as a single unit, but with the Father holding the Lamb forth as a sign both of generation and of what he offered for the restoration of man, yet with the Father remaining concealed behind Christ's less concealed concealment.

To take this a step further, Hugh said in an important passage in his commentary on Pseudo-Dionysius that two likenesses (*simulacra*) had been exposed to man in which it was possible to see the invisible: one of nature and one of grace (it should be remembered that the works of nature are the works of creation, and that the works of grace are the works of restoration). The likeness of nature is the outward appearance (*species*) of this world. The likeness of grace is the human nature of the Word. God is shown in both, but he is not understood in both, because while nature demonstrates its master craftsman by outward appearance, it is not able to illuminate contemplative vision. Since it is impossible for the invisible to be demonstrated unless through the visible, and since all theology necessarily has to use visible demonstrations in its disclosure of invisible things, divine theology chose works of restoration according to the human nature of the Savior and his sacraments, which are from the beginning of time, to accomplish this demonstration.[61] Now, the ultimate work of restoration is the passion of Christ,[62] and the last judgment is the last work of restoration or, in the narrowest sense, the actual restoration itself. These ultimate visible works of restoration act to illuminate contemplative vision and so to lead one to the ultimate invisible truth, the Trinity.[63]

This is by no means a comprehensive analysis of this part of the portal. It is only an attempt to indicate the profound degree of participation of Hugh in Suger's program—something which is distinct from his writings being illustrated in it. If Hugh's participation explains so many of the iconographical singularities of the portal itself, it also explains other more general but equally important observations which were not previously understood. These have been pointed out by many scholars, but most fully by Gerson. The clear organization of subject matter, the logic and clarity of composition, and the manipulation of imagery which scholars have had trouble associating with Suger may now be seen as the work of Hugh—however close Suger may have acted as the direc-

tor and originator of the program. The use of texts to create tightly knit constructions and the many levels of meaning noticed by Gerson are typical of Hugh's general approach. And the predisposition toward a literal interpretation of written sources is one of the main qualities for which his exegesis is known. The enormous bank of images from which "Suger" chose elements from different periods and traditions with an abandoned eclecticism, the tendency for "Suger" to take images from different sources and combine them to express something new when standard representations did not say what he wanted—both seem to stem from Hugh's literary, not artistic, bank of images, and can be noticed in his *De Arca Noe Mystica*, whose description of Noah's ark includes much of the imagery of the west central portal: the labors of the months; the signs of the zodiac; the twelve apostles; an image of the Lord with head, hands, and feet projecting from behind a disk; an association between the latter image, the elect and the damned, and the same passage from Matthew 25 used on the St-Denis tympanum; the Mystic Lamb in front of a cross; the association of the Lamb with the passion, resurrection, and ascension; a tendency to take existing imagery and alter it (for example, arranging the twelve apostles and twelve patriarchs "in the likeness of the Twenty-four Elders"); and so on.[64] The confluence of Augustinian and Pseudo-Dionysian thought noticed by Gerson is almost a definition of Hugh's theology.[65]

And so we see now why the use of imagery at St-Denis seems more sophisticated than Suger's use of words.[66] At the intellectual level, its sophistication was in all probability not the direct product of Suger. It was also literary-based, multilayered, and most of all, obscure. In fact, it was so obscure that much of the imagery was never copied elsewhere. What, then, was the relation of such a complex program to the public? Could the average person really have been expected to understand the meanings of these artworks, which have been forgotten for so many centuries?

No, he could not have.

6

SUGER'S RESPONSE:
NONTRADITIONAL JUSTIFICATIONS

Of all the criticisms of the monastic use of art to which Suger chose
to respond, those of materialism and art as a spiritual distraction
generated his most innovative justifications, and were those which
most affected the way his art program looked and the way in
which it has been viewed. For reasons which involve both the
process of historiography and Suger's understanding or lack of
understanding of Pseudo-Dionysian mystical theology, Suger's
justifications in response to those two criticisms—the claims that
external materialism could function anagogically and that art could
act as a spiritual aid—have come to be conflated with the question
of the influence of Pseudo-Dionysian thought in the art of St-
Denis. And so it is from the angle of Pseudo-Dionysian mysticism
that Suger's nontraditional justifications of materialism and art as
a spiritual aid will be approached.

As pointed out by M.-D. Chenu, the neoplatonic basis of both
Augustine and Pseudo-Dionysius resulted in a continual crossing
of their two distinct systems of thought in the twelfth century.[1]
This was no less true for Hugh of St-Victor, whom he describes as
responsive to Pseudo-Dionysian thought while remaining essen-
tially Augustinian. According to Chenu, the two systems put forth
entirely different theologies of symbolism as a means of under-
standing the divine realities that were their goals. For the purposes
of this study, the roles of Pseudo-Dionysian and Augustinian
thought in the art program of St-Denis may be distinguished
through their respective attitudes toward "symbol" and "sign."

In the Pseudo-Dionysian system, man's intelligence is of the
same nature with matter, and so has to employ matter to progress
toward divine realities. This involves an acceptance of matter in
the form of a symbol, followed by a transcending of matter, which
is anagogy.[2] The Pseudo-Dionysian symbol is by its very nature an

authentic and immediate expression of divine reality, and so its meaning comes not from anything invested in it by the believer. Indeed, enlightenment passes through the symbol to the mind. For art historians, a word like "symbol" and other words employed in the Latin translations of the Pseudo-Dionysian writings such as "image" and "likeness" make it easy to overemphasize the role of art in particular as a symbol. And while art may act as a Pseudo-Dionysian symbol, the examples of symbols cited by Pseudo-Dionysius himself are typically not art but rather sacraments, liturgy, sacred readings, and light.[3] In *The Celestial Hierarchy*, Pseudo-Dionysius gives a list of those images that are similar, those that are dissimilar, and those that are in-between. Those that are similar include the "sun of righteousness," the "morning star," and the like; those that are in-between comprise the fire of the burning bush that burns but that does not consume, and the imagery of the water of eternal life as overflowing the stomach in an endless river; those that are dissimilar include "fragrant ointment," "corner stone," and the like.[4] According to Pseudo-Dionysius, it is the dissimilar that is the most efficacious in the anagogical process. However, he specifically warns against "the more extravagant sacred forms" of the dissimilar as misleading, apparently because they characteristically tend toward the material. He cautions that one might be deceived into believing that heavenly beings actually had the appearance of gold, and so on.[5] Indeed, while he allows the use of forms from common matter since this, too, was made by God, according to Pseudo-Dionysius it is the more clear and plain symbols that are of the greatest value.[6] Moreover, the Pseudo-Dionysian symbol is not a symbol in the sense of a conventional symbol. It is not something that stands for another thing. It is not open to analysis, and it is not related to scriptural or sacramental allegorizing. Anagogy is a spiritual ascent from the material to the immaterial, from the visible to the invisible. It comes about through the natural dynamism of symbols, and, as Chenu explicitly points out, it in no way involves a simple psychological transference or aesthetic interpretation. Nor is the image of the transcendent "some pleasant addition" to the natures of the symbols. Finally, the Pseudo-Dionysian system discounts the importance of scriptural history, including the acts of Christ.

49

In contrast to the symbol of the Pseudo-Dionysian system whose meaning is not invested by the person using it, the sign of the Augustinian system does receive its value from that person. Rather than acting in an anagogical manner, the sign conveys knowledge. It is conventional and meant to be analyzed, although it can be obscure, and in this process the mind is understood as being enlightened directly, rather than through the sign. Faith is essential in understanding signs, and without faith there can be no understanding of the spiritual sense of Scripture. Indeed, far from discounting the importance of Scripture, the Augustinian system provides the means for grasping the future soteriological and eschatological significance that the past holds for the present through the structure of Scripture—this being the exegetical function of history in Scripture. This is so much the case that according to Augustine, anything that cannot be understood in Scripture as directly relating to morality or faith is bound to be figurative. Thus, I believe, it is the sign of the Augustinian system and not the symbol of the Pseudo-Dionysian that permeates Hugh's *De Sacramentis*.[7]

"God is light." "All that is perfect . . . descends from the Father of Lights." "[God] lives in unapproachable light." "The invisible things of God's . . . are understood through those things which have been made." "For from the greatness and beauty of creation, the creator of these things is able to be understood." "We have lingered long enough on those things which God has made in order that through them he who made them might become known." "From corporeal and temporal things we may grasp eternal and spiritual things." "The intellect should be cleansed so that it may be able to perceive the light." These are not passages from Pseudo-Dionysius; they are from the New Testament and Augustine.[8] Given this biblical and patristic tradition of light vocabulary and of the material leading to the immaterial on the one hand, and the distinction between symbol and sign on the other, the question arises as to exactly what is Pseudo-Dionysian about Suger's art program.

It is significant that in *De Consecratione*, Suger never mentions light in relation to Pseudo-Dionysian light mysticism, and yet the

two passages in *De Consecratione* which attempt to put forth a Pseudo-Dionysian justification of art comprise his most extensive effort toward exploiting such a justification.[9] Suger opens *De Consecratione* with a passage so confused, so rambling, that even Panofsky failed to recognize it as Pseudo-Dionysian—Suger's was hardly the mind that created the sophisticated iconographical schemes of the west central portal or of the allegorical windows. The introduction, which is related to the conclusion of *De Consecratione*, is not "an organ prelude filling the room with magnificent sound before the appearance of a discernible theme," but a statement of Pseudo-Dionysian principles.[10] In both passages, Suger strained to relate Pseudo-Dionysian thought to his own goals. But Pseudo-Dionysian anagogy is barely hinted at through reference to "the similar and the dissimilar." Instead, he emphasizes the component of the material in the Pseudo-Dionysian anagogical equation out of all proportion, coupling this with an exaggerated denial of interior materialism and of appeal to the senses at St-Denis—all of which was meant to act as a justification of that monastery's exterior materialism.[11] In the process, he attempts to integrate his justification of reciprocity, as if the former supported the latter. Fairly well-decorated with Pseudo-Dionysian language, what Panofsky took for an organ prelude is indicative of Suger's superficial use of a Pseudo-Dionysian justification of his art program, but one that is characterized by the absence of any real philosophical application of Pseudo-Dionysian theory.

Suger apparently was uncomfortable enough with his overt discussion of Pseudo-Dionysian mystical theology in *De Consecratione* to avoid it in the later *De Administratione*. In place of the earlier, unconvincing attempt at an actual philosophical discussion, Suger now only records, without comment, one inscription which makes Pseudo-Dionysian and anagogical claims, and relates in another place what he describes as personal anagogical practice involving non-figural art.

The Pseudo-Dionysian inscription amounts to no less than an attempted justification of the entire program, placed as it is on the gilded bronze doors at the entrance to the church where it announced itself to all who approached. The opening lines reveal the inscription's primary concern:

Whosoever of you seeks to extol the glory of these doors,
Admire the craftsmanship, and not the gold or expense.

(*Portarum quisquis attollere quaeris honorem,*
Aurum nec sumptus, operis mirare laborem.)[12]

The justification is clearly and intimately related to the denial of materialism, counting heavily on the claim of craftsmanship over material which has already been mentioned.

However, beginning along traditional lines, it quickly moves to an evocation of the nontraditional:

The noble work is bright, but a work that is nobly bright
Should brighten minds, so that they may pass through true
 lights
To the true light, where Christ is the true door.
The golden door indicates in what way it [the true light,[13] i.e.,
 the divine] may be within these things [the lesser true
 lights, i.e., the artworks].[14]

(*Nobile claret opus, sed opus quod nobile claret*
Clarificet mentes, ut eant per lumina vera
Ad verum lumen, ubi Christus janua vera.
Quale sit intus in his determinat aurea porta.)

On a superficial level, the inscription is such a clear presentation of Pseudo-Dionysian mystical theology that, after his clumsy attempt in *De Consecratione*, one wonders if in fact Suger was helped in this central justification by someone like Hugh.[15] But despite the strong Pseudo-Dionysian language, the concept is ambiguous, and a close reading reveals that it is not the brightness of Pseudo-Dionysian light mysticism that operates in the illuminating experience which is described, but rather the traditional spiritual brightness of the events depicted in the different "lights" or scenes on the door—particularly the assumption of material existence on the part of Christ. Indeed, the theme of the material Christ as an intermediary to the immaterial Father, which is a repetition of one of the major themes of the portal sculptures already discussed, is traditional.

The inscription concludes:

The dull mind rises to the truth through material things
And, having seen this light, arises from its former submersion.

(*Mens hebes ad verum per materialia surgit,*
Et demersa prius hac visa luce resurgit.)

Thus, while the language and much of the general idea is unmistakably Pseudo-Dionysian, the reference to the passion and resurrection cycles of the door indicates their traditionally meditative function, not Pseudo-Dionysian which as Chenu pointed out does not concern itself with the historical reality of Christ. That is, Suger is overtly using Pseudo-Dionysian language and thought in his art program in a way that gives more attention to its justificative potential against charges of materialism than it does to its mystical intent—and he announced this justification in the most public way possible.[16] This justificative manipulation is compounded by the contradiction between the evocation of a claimed anagogical function and the reality of the traditional spiritual function of the doors which is the same as that of the tympanum: they are spiritual aids in the sapiential, Augustinian sense of sign, not the Pseudo-Dionysian sense of symbol.[17] They are spiritual aids in the same sense as described as legitimate in one of the letters of Gregory the Great which advocated the use of visible things as a means of demonstrating invisible things (*per visibilia invisibilia demonstramus*)—singling out as proper meditative subjects for art precisely those two areas singled out by Suger on the door, the passion and the resurrection.[18]

The only other overt Pseudo-Dionysian reference in Suger's writings is that which claims to relate his personal anagogical experiences involving precious stones.[19] In this passage, Suger describes how when gazing at certain liturgical artworks—he singles out the Cross of St Eloi (fig. 6) and the "Crest" of Charlemagne (fig. 7)—he would meditate on "the diversity of the sacred virtues" of the precious stones and, "having been conveyed from material things to immaterial things," he would on occasion enter a trance-like state that he describes as somewhere between heaven and

earth.[20] Again, the language is Pseudo-Dionysian, and for the first and only time in all of Suger's writings and inscriptions the word "anagogy" appears.

Whereas the implied anagogy of the door inscription was more evocative than it was philosophically correct, this reference to the anagogical use of the multicolored gems mentioned by Suger corresponds more closely to the concept of symbol as used by Pseudo-Dionysius than does the figural art of the west end. To be sure, it seems that the reason why this is the only passage in which the word "anagogy" appears, and why it is specifically associated with precious stones, is that Suger is basing himself on the only passage in Pseudo-Dionysius which may be said to be even indirectly related to art per se: a short passage toward the end of *The Celestial Hierarchy* which mentions the anagogical properties of precious stones.[21] It appears in the passage on the high altar because the Cross of St Eloi and the Crest were probably part of the furnishings assigned to this altar in particular,[22] and so they could be discussed when the altar was discussed. I say "could be," because the reason they are mentioned at all is to act as a vehicle for *The Celestial Hierarchy's* reference to anagogy and precious stones, and in their connection with the high altar appear as the first nonfigural liturgical artworks touched upon by Suger.

The passage's justificative function in the text is clear from its placement in the middle of a chapter which in giving an account of the high altar moves from justification to justification with little regard for the flow of logic. In this single chapter Suger moves from reciprocity to the issue of craftsmanship and material, to art as a spiritual aid (which I will soon take up), to a denial of materialism, to the anagogical function of art, to supraregional claims for the art of St-Denis, to art for the honor of God, to the Old Testament justification of art, and back to reciprocity. Suger is simply listing justifications, and this offered the best opportunity to insert the one passage from Pseudo-Dionysius that gave the appearance of applying directly to art. Furthermore, considering how closely this passage follows Pseudo-Dionysius, the similarity of concept between it and an account of spiritual ascent described by Hugh in *De Arca Noe Morali*—including contemplation, the imagery of being somewhere between heaven and earth, and visible

and invisible things—suggests that Hugh or his writings may have stimulated Suger in his written presentation of art-induced anagogy.[23] Nevertheless, the claim is made only on the personal level, unlike most of the other justifications in Suger's writings, as if Suger were aware that he had to be cautious here.

There may have been another reason for the references to Pseudo-Dionysius on the facade of St-Denis and in Suger's writings, one not strictly related to the justification of art. Panofsky and von Simson have shown the importance of Pseudo-Dionysius politically and, as they saw it, anagogically. But their political reference was strictly secular. There is another political reference that seems to have been at play in the adoption of the patron saint's philosophy. And this is that Pseudo-Dionysian "theology" was seen by contemporaries as opposed to the more worldly "philosophy" currently making headway in the schools. In the very opening passage of his commentary on *The Celestial Hierarchy*, Hugh writes:

> "The Jews seek signs, and the Greeks wisdom" [1 Cor. 1:22]. Indeed, there was a certain wisdom which seemed [to be] wisdom to them, those who did not know true wisdom. And the world acquired that wisdom, and began to be puffed up and was swollen—in this considering itself great. It presumed and said that it had passed beyond to the highest wisdom. . . .

Elaborating on the idea that the wisdom of God cannot be found in secular learning, Hugh continues,

> [But God] showed another wisdom which seemed [to be] foolishness [cf. 1 Cor. 1:21] and was not, so that true wisdom might be found through it. The crucified Christ was made known, so that truth might be sought in humility.[24]

Later saying that Dionysius left "philosophy" to become a "Christian theologian,"[25] Hugh rejected the learning personified by Bernard of Clairvaux's arch-enemy, Abelard, and at the same time embraced a world of elite knowledge, but knowledge that was acceptable to the reform party. Through Pseudo-Dionysius, and, as I believe, Hugh, Suger could claim an association with Bernard's party in his rejection of the "reason" of Abelard and his circle over

the "supreme reason" of the divine—which he mentions three times in the opening passage of *De Consecratione*[26]—and at the same time use Pseudo-Dionysius to justify an attitude toward art rejected by that party. Such a position, however, should not be seen as directly applicable to the formation of Suger's art program per se, and even then is present only in relation to the degree that reference is made to Pseudo-Dionysian theology.

In the end, the effective role of Pseudo-Dionysian mystical theology, especially light mysticism, in the actual formation of the art program of St-Denis must be seen in perspective. There are only four overt uses of Pseudo-Dionysian mysticism in all of Suger's writings. The two in *De Consecratione* are so confused as to carry little or no significance beyond an attempted and strained denial of materialism, and neither refer explicitly to either art or light. Of the two in *De Administratione*, both make similar denials of materialism, and both also make anagogical claims. But the word "anagogy" actually appears only once in all of Suger's writings—far less than in the first page of *The Celestial Hierarchy* alone; and then its anagogical claim is made strictly on the personal level, and solely in regard to nonfigural art, not the figural art of the major components of the program. Furthermore, in the more important passage of the two, anagogy is only implied and implied in a way that, as Suger uses it, has no firm basis in Pseudo-Dionysian thought but rather is based on a traditional meditative function of art. This same passage contains the only reference made to light in association with Pseudo-Dionysian mysticism in all of Suger's writings and artworks. Despite its significant appearance in the inscription on the doors, the reference is made in a manner that uses Pseudo-Dionysian language in an evocative way, not in a way that has an actual philosophical foundation in Pseudo-Dionysian thought—and then only in reference to the splendor of metalwork, not in explicit connection with Pseudo-Dionysian light mysticism and actual sunlight or the appearance of the innovative Gothic windows. All in all, the justificative claims of Suger may have a patina of Pseudo-Dionysian thought, but the philosophical core is Augustinian—whether or not Augustine would have approved.[27] Their purpose is primarily to act as denials of materialism, and light mysticism does not play a principal part.

There is still one other passage that lends itself to a Pseudo-Dionysian interpretation, the passage dealing with the most innovative feature of the program at St-Denis—indeed, one of the essential elements of Gothic—the stained glass windows. By his own account, Suger had a great variety of painted windows installed in the course of his reconstruction of St-Denis.[28] The subjects of a number of the chevet windows are known, and they deal with such themes as the tree of Jesse, the infancy of Christ, the passion of Christ, the pilgrimage of Charlemagne and the First Crusade, and so on.[29] However, Suger chose to refer to only two of them at any length in his writings and then for the most part only recording their verse inscriptions. These are the so-called Allegorical Window and the Life of Moses Window, windows whose meanings are not yet fully known and which present their subject matter in a series of relatively obscure, symbolic images in the former, and seemingly straightforward historical scenes in the latter. The passage recording the inscriptions of these windows has been felt to be evidence of Pseudo-Dionysian mysticism, despite the fact that light is never mentioned in connection with them, because of its phrase, "urging [one onward] from material things to immaterial things."[30] However, Suger in no way says that the windows in general urge their viewers onward from material things to immaterial things. He says that *"one* of these" windows, that is, panels, urges its viewers onward from material things to immaterial things, and this panel is the introductory panel of the Allegorical Window (fig. 8). Louis Grodecki, who was unconvinced of a strong Pseudo-Dionysian influence in the art of St-Denis, has shown the exegetical character of this and other panels in the window.[31] But Grodecki and others have felt that the reason that Suger included the inscriptions of the windows at all in his account of the art program was because of his vanity toward his own verse. While this is not the place to take up the meaning of Suger's panels, the reason that he chose to record the inscriptions of these panels is fundamental to his justification of art at St-Denis.

Grodecki was quite right in his interpretation of the general exegetical character of the window. This was especially the case for the introductory panel, the Mystic Mill, now lost (cf. fig. 9), whose inscription announced,

By working the mill, Paul, you remove the flour from the husk
 (*furfure*).
You make known the innermost secrets of the Mosaic law.
The true bread is made from so many grains without husk,
And becomes our and the angels' perpetual food.

(*Tollis agendo molam de furfure, Paule, farinam.*
Mosaicae legis intima nota facis.
Fit de tot granis verus sine furfure panis,
Perpetuusque cibus noster et angelicus.)[32]

However, not being able to find the source for this panel, he suggested that it simply may have been a personal invention of Suger's. But given the predominance of Augustine in Hugh's thought, and given the apparently high degree of participation of Hugh in at least the more intellectually demanding aspects of the program, it seems to be no coincidence that Augustine uses a similar metaphor in at least two important instances. In a passage from *In Johannis Evangelium* dealing with how the senses may be used to rise from the "visible" to the "invisible" by means of the study of Scripture—a passage which makes reference to Paul and which is followed by one which mentions the "true bread"—Augustine writes:

By the five loaves are understood the five books of Moses, which since they pertain to the Old Testament are rightly not of wheat but of barley. Now, you know that barley is so made that its kernel is not easily got. For this kernel is clothed with a covering of husk (*paleae*), and the husk itself is tenacious and firmly attached so that it may be removed [only] with effort. Such is the letter of the Old Testament, clothed in a covering of carnal sacraments—but if its kernel is got, it nourishes and satisfies.[33]

And in another passage on the figurative or allegorical aspect of the more obscure passages in Scripture from *De Doctrina Christiana*, a work that amounts to a handbook on Christian exegesis, Augustine again notes that "all these things are figural, whose secrets are to be removed from the husk (*enucleanda*) as the food of charity."[34] What urges one onward, then, from material things to immaterial

things is not any anagogical function either of the image or of the sunlit window itself, but rather the traditional exegetical study of Scripture, to which in one of its earliest artistic expressions this panel serves as an allegorical introduction and justification based on Augustine apparently by way of Hugh.

According to Augustine's theory of exegesis as presented in *De Doctrina Christiana*, all doctrine is made up of either things (*res*) or signs (*signa*).[35] A "thing" is something that is not used to signify something else; that is, it is something that may be taken literally. A "sign" is something that is used to signify something else, the same Augustinian use of the word as before. That which is visible can lead one to that which is invisible, and both that which is similar and that which is dissimilar can aid in the process of spiritual growth. Signs are either literal or figurative, "figurative" being more or less what Hugh would describe by the exegetical terms "allegorical" and "tropological." Scripture can have several levels of meaning at the same time, and the meanings of some things are either not understood at all, or only partially understood. Whatever in Scripture does not relate to upright living or faith is figurative, but all that is figurative is not for everyone.[36] These things should never or only rarely be put before a "popular audience," with books and "certain conversations" being exceptions. That is, a gradation of different levels of spiritual knowledge is part of this system of exegesis, with the possession of increasingly exclusive knowledge toward the top.[37] An important part of this gradation is the factor of obscurity, which is multifaceted. Obscurity acts to subdue pride, to exercise minds, and to stimulate the desire to learn. For "when something is sought with difficulty, it is found with a great deal of thanks," and "the greater these things seem to be obscured by figurative words, the sweeter they become when they are revealed." Obscurity also serves to conceal the mysteries from the impious.[38]

At the time of the undertaking of the windows of St-Denis, the Victorine school was one of the two most important centers of exegetical thought, exegetical thought being then the recognized approach to scriptural study, scriptural study being the equivalent of theology, and theology being the only legitimate field of learning according to standard ecclesiastical thought. Hugh was the leading

thinker of the Victorine school. And Hugh's exegesis was based on Augustine's *De Doctrina Christiana*.[39] Without going into the details of Hugh's Augustinian based thought on scriptural study, let me just point out in relation to the Mystic Mill that Hugh recommended the Epistles of Paul in the study of allegory above all other books of the Bible. He felt that allegory educates one in faith, and that through the study of Scripture one is raised up to the heavens. Reading and meditation are the chief things that lead one to knowledge. And contemplation, which he rated as the means of achieving the highest of all fifteen steps toward spiritual perfection, allows one to rise above everything.[40] Finally, paraphrasing Augustine, Hugh enthusiastically took up the idea of the positive aspect of obscurity, noting that it conceals the sacred from the unworthy, stimulates the desire for greater knowledge on the part of the believer, and through it spiritual progress is made.[41]

If art did not mix well with spirituality to Augustine, it certainly did to the Augustinian Hugh.[42] As I have mentioned, Hugh himself had drawn an astonishingly complex miniature to elucidate his great mystical work, *De Arca Noe Morali*. In introducing the miniature to his meditative audience, Hugh said:

> The model of this spiritual building that I am going to present to you is the Ark of Noah, which you will see with your eyes so that your soul inside may be made in its likeness. You will see there certain colors, forms, and figures which may please the sense of sight. But for this reason, you should know that these have been put there in order that you may learn in them the wisdom, discipline, and especially the *virtus* which ought to adorn your soul.[43]

Colors, forms, and figures—these amount to no less than the Augustinian sign, as opposed to the Pseudo-Dionysian symbol. But it is the integration of the text and the meditative work of art (whose appeal to the senses is to be subordinated) into a complementary relationship that is of real significance for our study. In Hugh's book, it is a meditative work of art that helps elucidate the text. In Suger's artwork, the process is simply the other side of the same coin: the text helps elucidate the meditative work of art.

It was no accident that Hugh said reading and meditation are

the chief things that lead to spiritual knowledge. Reading was traditionally recognized as the foundation of monastic life and spirituality, in short, of monastic culture. This was so much so that in Benedictine terminology the word *meditatio* indicated a form of meditation of which spiritual reading formed the basis.[44] This explains what Suger meant concerning the reliefs of the high altar:

> Because the diversity of the subject matter of the gold, gems, and pearls is not easily understood by the mute perception of the sight without a description, we have seen that the work—which is accessible only to the *litterati* and which is resplendent with the radiance of delightful allegories—be committed to writing. Indeed, we have affixed explanatory verses to it [the altar] so that they [the allegories] might be more clearly understood.[45]

The key phrase is "accessible only to the *litterati*." Suger specified this distinction for a very important reason. A *litteratus*, as Suger uses the term, was not simply a person who could read, but a monk who was educated in scriptural study. In monastic circles the term *litteratus* carried the implication of "choir monk," that is, the standard monk who was capable of reading and so of performing the textually based *opus Dei* as opposed to the *idiota*, the illiterate monk or *conversus*.[46] The "diversity" or lack of overt correspondence of the reliefs was the exegetical correspondence of type and antitype. Long a regular feature of written exegetical study, the typology of Suger's reliefs is among the earliest examples in later medieval art. As such it must have been very novel to its viewers and required a certain prompting in Suger's view in order to indicate that typologies were indeed being employed in an artwork. Not only did one have to be literate just to read the prompting inscriptions, but the claim was that one had to be a *litteratus* to further understand what was meant in the artwork. This relationship between reading and art, on which the altar reliefs depended, was also the premise of the window panels.

Based not just on Scripture but on scriptural study, the altar reliefs and window panels could have many different levels of meaning. Even the more obvious levels of meaning of the Allegorical Window would probably not have been accessible without a

firm grounding in the Fathers. And since exegesis seeks to clarify the often obscure presentation of Scripture in order to find its hidden spiritual meaning—removing the grain from the husk—Suger introduced what he apparently felt to be the most important of all the panels with the expression, "urging one onward from material things to immaterial things," a concept referred to by Augustine in his *De Doctrina Christiana*. By presenting scenes of exegetical complexity, art was now claimed to take on the undeniable spiritual benefits of scriptural study, an area of spirituality that had traditionally been the reserve of the *litterati*.[47] It seems that a parallel function was claimed between this new type of art and the traditional process of scriptural study and meditation—not in the sense of a formal process of first reading and then meditating before the artwork, but rather in the sense of one who is a *litteratus* and so is well read using the artwork in some informal way as part of his spiritual exercises during the periods set aside in the monastic day for personal devotion. That is why light is never mentioned in connection with the windows. As a spiritual aid they were based on traditional scriptural study and the sapiential tradition of the material leading to the immaterial, not on Pseudo-Dionysian light mysticism.[48] The so-called Anagogical Window (the Allegorical Window) is not primarily anagogical at all. This is not to say that there could not have been absolutely any anagogical function to the windows, only that there was no primary anagogical function, that Pseudo-Dionysian light mysticism was not primarily responsible for the Gothic window at St-Denis.

And so if the art of St-Denis is obscure, it is the conscious, theological obscurity of a professional theologian, Hugh, and not the idiosyncratic obscurity of Suger's personal whims. Like Scripture, its more obscure meanings were accessible only to the advanced. And like the obscure secrets of Scripture, this was not put before— or in this case made for—a popular audience. And that is just the point of Suger's recording of the inscriptions of the altar reliefs and window panels. Suger did not record the inscriptions because he was vain concerning them any more than he was vain concerning his theory of reciprocity. He recorded them because they indicated the obscure, literary nature of a purposefully thought out art that was not understandable to "the people."[49] They were an impor-

tant part of the justification of his program, perhaps the most important part. This art was emphatically not to educate the illiterate, and Suger went to great pains to make that point clear. If Suger mentions his concern with the visitor's view of the artworks twice in *De Consecratione*, he never does in *De Administratione* where he is more conscious of the criticism of art as a spiritual distraction.[50]

In *De Administratione* his attitude has changed. This new art was accessible only to the *litterati*: it was an intellectually/spiritually advanced art which acted as a spiritual aid and which was claimed to be only for monks. Although not universally so, this type of art was programmatic at St-Denis. Its presence dominated, as we have seen, the windows and the liturgical art of the abbey. It also dominated the sculptural program. In that much of the iconography of the tympanum of the west central portal is specific to the subject of the last judgment proper, it is part of a complex presentation of the theology of the judgment, and so on one level simply deals with an aspect of Church doctrine fundamental to all members of the Church. But in that there is a level of meaning which is removed from the specifics of the last judgment per se, that is, the process of "the illumination of contemplative vision," its imagery has crossed the line from a straightforward theological exposition to something else, something whose obscurity required sophisticated analysis. In this sense it, too, was meant to claim the function of art as a spiritual aid to the *litterati*. And yet the use of art as a spiritual aid was not new. Many artworks had existed previously which demanded a high level of knowledge and sophistication to understand their meaning. What was new was Suger's explicit definition of an art for monks through its exegetical basis and his justification of the use of this art by "spiritual men."[51] In this Suger could make the claim that his art was in agreement with the currently often quoted saying of Jerome: "The monk does not have the function of a teacher, but rather of a mourner."[52] But as we have seen with so much of Suger's program, the claim is not necessarily the same as the reality, and the reality of Suger's program involved something more.

7

THE CONTRADICTION

The contradiction inherent in Suger's claim was, of course, the reality that the windows and most of the other artworks listed by Suger as accessible only to the *litterati* were visually quite accessible to the illiterate as well. As Hugh put it in a passage on beauty in the *Didascalicon*,

> In the same way that an illiterate who may look at an open book sees figures (*figuras*) [but] does not understand the letters, so the foolish and carnal man who does not perceive those things which are of God [1 Cor. 2:14] sees the external beauty in certain visible created things but does not understand the interior reason. However, he who is spiritual and is able to discern all things, in that he has considered the external beauty of the work, comprehends interiorly how wondrous the wisdom of the Creator is. . . . The foolish man wonders at only the beauty in those things; but the wise man sees through that which is external, laying open the profound thought of divine wisdom. Just as in the same passage of Scripture the one will commend the color or the form of the figures, so the other will praise the sense and the signification.[1]

In the same way, the most stunning and visually effective of all Suger's works of art and one of the key elements of Gothic architecture, the stained glass windows, comprised in their most important examples an almost constant ornamentation of the ambulatory which, in whatever other way it may have been used by the monks, was by its very definition and by Suger's repeated implication designed for the reception of laymen at St-Denis. It was no accident that they lined an ambulatory whose ambiguity in its double-aisled design—at once chapel space for the monks and viewing space for the pilgrims—mirrored the double function of

64

the windows.[2] And it was just these overwhelming works of art that were the focus of Suger's most important justification, art as a spiritual aid, which claimed to refute the charges of art as a spiritual distraction. While this art was claimed to function spiritually for the monk, in reality it also functioned visually as part of a sensory saturation of the holy place which combined with the liturgy and the proximity of the sacred to overwhelm the visitor. If one takes Suger's writings as indicative of what he saw as important to himself and to his contemporaries—and there really is no other way to take them—one sees that Suger was not primarily concerned with the potential light symbolism of the windows, nor was he primarily concerned with the new aesthetic of the architecture, neither of which are ever mentioned in his texts.[3] What he was primarily concerned with in the windows, once one moves away from the justificative level, was saturating the church with imagery and the visual effect of that imagery.

Suger refers to the saturation of the church with imagery when, in his only formal discussion of the windows, he describes their great variety and alludes to their arrangement.[4] Their general effect is described in both his and William of St-Denis's ingenuous comments about the windows as "shining," with Suger further characterizing the light from the ambulatory windows as "uninterrupted" (fig. 10).[5] As Panofsky pointed out, the description of the light from the ambulatory windows as uninterrupted refers to the new skeletal system of construction. This was something that was absent in the earlier pilgrimage churches as well as in the ogival but theoretically imageless pierced-wall windows of contemporary Cistercian churches. As important in effect as the uninterrupted design of the windows was, it was only one factor along with the relative height of the windows to the wall and their absolute distance to the viewer that tell us just how much the visual effect of the windows mattered to Suger.

It is striking how dramatically Suger altered the common relation of the window to the potential viewer's field of vision at St-Denis in order to increase their effect. For example, at the great pilgrimage church of Santiago, the pierced-wall windows of the chapels of the ambulatory comprise only around twenty-five percent of the total wall surface into which they were set (fig. 11).[6] At

Conques, they accounted for around twenty-eight percent. At Cluny, at St-Martin-des-Champs which Jean Bony describes as having served as one source for St-Denis,[7] and at the Cistercian Fontenay, the relative window heights of the main apse windows are still only around fifty to fifty-two percent. But even a relative window height of fifty percent did not provide a powerful enough effect for Suger, whose ambulatory chapel windows are comprised of glass surface for no less than seventy-five percent—three times that of Santiago—of the total height of the wall surface into which they are set. Just what a conscious effort this entailed is suggested by the ambulatory chapel windows of Noyon (ca. 1150–1185), which Bony says closely followed St-Denis,[8] where the relative window heights nevertheless continue to employ the earlier arrangement of around fifty percent.

Expressed in absolute terms indicative of the viewer's relation to the window itself, the distance from the floor to the bottom of the glass at St-Denis is around one and a third meters, while at Santiago that distance is around four and a half meters—almost three and a half times further away than St-Denis despite the fact that the wall surface at Santiago is only around two-thirds meter taller. At Conques this absolute distance is around five and a half meters (fig. 12), at Cluny around three and a third meters, St-Martin-des-Champs around three meters, Fontenay around three meters, and Noyon around three and a quarter meters, although all of these churches except Conques range from less than one meter to only around one and a third meters higher. Indeed, the sills of the stained glass windows at St-Denis are so low that today many of them are partially covered with retables that have been put there in modern times.[9]

The question of the technical and aesthetic development of the Gothic skeletal system is beyond the scope of this study. But Suger's almost constant awareness of the need to justify his art program may account for at least one factor among several in the skeletal system's appearance at St-Denis in particular. As mentioned before, Bernard of Angers had referred to what he described as a general tradition in most regions, a tradition which because of the tendency of the "illiterate" toward idolatry rejected the use of free-standing sculpture except for the crucifix and which approved of

66

the depiction of the saints only in manuscript and mural painting. Cistercian art legislation and practice of this time reflect an almost identical position to that of Bernard of Angers: while all sculpture and painting were prohibited from their monasteries, the painted crucifix was legally excepted and figural imagery in manuscripts apparently continued for some years (probably on the basis of individual interpretation of the law which literally excluded it) before being formally banned. While not wishing to overemphasize the point, the main free-standing sculpture in Suger's program was a crucifix, with no free-standing sculpture of St Dionysius being mentioned; and functionally—although not necessarily iconographically—Suger's stained glass windows replaced murals. But it was not just that the windows came to replace murals physically, they also seem to have been equated with murals conceptually, an equation between murals and stained glass being understood in Theophilus's preface to his book on glass.[10] It seems that Suger's windows carried the connotation of a traditionally approved art form although they were more or less new, as Suger used them, in format and effect.[11]

And so it seems that Suger took an art form which he could at least claim as "traditionally" acceptable and which had previously presented itself to the viewer's field of vision as relatively distant, short, narrow, and widely separated by large expanses of wall surface, and expanded it to a closer, taller, wider medium with radically less masonry separating the almost "uninterrupted" encircling of brightly colored light surfaces, thereby enormously increasing both relatively and absolutely the presence of the glowing, sun-animated windows in the viewer's field of vision.

But it was not just a question of vastly increasing the window surface area and bringing it down face to face with the viewer. The windows were also brought into a coordinated arrangement through the shallow chapels in which all of the windows were working toward the same overwhelming effect of sensory saturation, as opposed to the independently working, isolated windows cut off by deep chapels of the older design (cf. figs. 10 and 13 with figs. 11 and 14). Taking the occasional and the removed, Suger transformed it into an immediate and powerful experience which must have been visually overwhelming to those to whom it was a

new art form—so much so that one may say that whereas in the west end Gothic structure is employed, in the east end Gothic structure is exploited.[12] Perhaps it was to the stained glass windows that William of St-Denis referred when he wrote: "you paint for yourself the heavens and the gods of the heavens in [your] church."[13]

This taking of preexisting elements, the skeletal system and the stained glass window, and pushing them to the limits seems to have been primarily based on the desire to exploit the direct effect of the window rather than the effect of the architecture or even of the two together. The nature of that exploitation seems to have been one mutually worked out by Suger and the second master,[14] the latter providing an aesthetic solution to the former's functional requirements. The new architectural aesthetic as it was worked out at St-Denis was secondary to the desire for a more effective—or dazzling, depending on the point of view—form of art: it was not part of the initial equation. It was no coincidence that it was just when under Suger's direction murals began to be systematically replaced with ever more powerful windows, and windows were multiplied, enlarged, and justified as a spiritual aid for "spiritual men" that, probably 1149/1150, the Cistercian Order itself was compelled to issue legislation proscribing color and imagery from the windows of its own churches, something which was already technically covered by previous legislation. If the artistic asceticism of the Cistercians had had its effect on Suger, then Suger had also had his effect on the Cistercians—enough of whom apparently had been seduced by this very effective art form which had been pushed to the limits by a quintessentially traditional Benedictine.[15]

8

CONCLUSION:
THE SUGERIAN SYNTHESIS

When Suger was installed as abbot, his inherently traditional attitude toward art was confronted with the challenge of artistic asceticism. In varying degrees, artistic asceticism had been a constant throughout the Middle Ages. But it was only with the penetrating criticism of the role of art in the Cult of the Dead and in the Cult of Relics by the Cistercians, and above all by Bernard, that it gained a force which demanded that it be addressed, in whatever way, by all frontline monasteries. It was no longer the "glowing" church of St-Denis that was representative of the cutting edge of monasticism, but rather the bare walls of Clairvaux.

The new monastic reform movement had criticized the use of art within the monastery as part of a larger body of criticism of monastic life. But if the general reform movement threw traditional monasticism into a state of self-review, it was not one that was absolutely polarized, and many members sought a middle-ground solution to the questions raised. Furthermore, reform—whether extreme or middle-ground—was contemporary, and contemporaneity was necessary to one degree or another for the prestige of those monasteries that claimed to be frontline. In order to give the appearance of contemporaneity, Suger felt that it was in the abbey's best interests to be associated with middle-ground reform: to cloak his traditional position in the appearance of contemporaneity. In order to be able to make this claim institutionally, he undertook what he, if no one else, called a reform, a reform that seems to have involved no substantive changes.

The general situation in regard to art was similar. While in no way adopting all the tenets of the more extreme reformers, many members of traditional monasticism sought a middle-ground solution to the question of the role of art in the monastery. And just

as Suger was more concerned with appearance than with substance in his claim to a middle-ground institutional reform, so was he more concerned with appearance than substance in his claim to a middle-ground solution to the question of the monastic use of art. Not responding so much to the challenges of Bernard and the Cistercians as to the state of questioning effected by them within mainstream monasticism, Suger answered the traditional criticisms of luxury, ritualism, certain aspects of materialism, and so on, with the traditional justifications of art for the honor of God and the saints, Old Testament precedent, encouragement by God and the saints, reciprocity, and some other less central justifications.

But traditional justifications were not enough. The nontraditional criticisms had questioned the social, economic, and spiritual role of art within the monastery. As much as Suger might have liked to indulge himself in his inherently traditional attitude toward art, he was obliged to respond to at least some of the nontraditional criticisms then current in the panmonastic debate in order to give the appearance of competing with artistic asceticism on the intellectual/spiritual level. However, he did so selectively, addressing only certain aspects of the criticisms of materialism and art as a spiritual distraction.

Basic to Suger's denial of materialism was the authority of the writings of the abbey's patron saint. Referring vaguely and confusedly to the mystical theology of Pseudo-Dionysius, Suger tried to justify the materialism of his luxurious art program on the grounds of the Pseudo-Dionysian position that one is led to the immaterial by means of the material. Far more of a defense—or rather a denial—of external materialism than an expression of a philosophically based Pseudo-Dionysian anagogy, this constitutes Suger's main use of that thought as it applied specifically to art. Also, Pseudo-Dionysian thought as the philosophical system of the patron saint of St-Denis may have been generally evoked as an alternative to the "secular philosophy" of Abelard and his circle, but probably more for political reasons of aligning St-Denis with Bernard's party than as any concerted condemnation of the new thinking itself.

In regard to the charge of art as a spiritual distraction, the ex-

treme reformers argued that since the traditional function of art in the Church was to educate the illiterate, and since the education of the spiritually illiterate was the duty of the episcopacy, there was no reason for monks to employ such art which only distracted the spiritual man. Suger answered this line of reasoning with the justification of art as a spiritual aid, more specifically with the justification of art as a spiritual aid for the *litterati* or choir monks. Very much dependent on an accomplished knowledge of patristic literature for an understanding, Suger's art used obscurity and exegetical method as justifications for its existence: it was accessible only to the *litterati*. The unconvincing evocations of Pseudo-Dionysian mysticism with which Suger—who had a poor understanding of that mystical theology—veiled the traditional meditative, not anagogical, function of his art program have concealed its Augustinian foundation. It is the Augustinian sign, not the Pseudo-Dionysian symbol, that informs Suger's iconographical program and, consequently, invests it with an almost indisputable and universally acceptable source of authority in Augustine. If Pseudo-Dionysian light mysticism has been thought in the past to have been a primary force in the formation of Suger's art program, this is the result of a confusion of the various justifications of Suger in relation to Pseudo-Dionysian mystical theology in general, and of Suger's misleading evocation of it in relation to the traditional meditative function of religious art in particular. Light was never mentioned in relation to Pseudo-Dionysian light mysticism or the stained glass windows: it did not play a principal part in artistic change at St-Denis.

From the almost formulaic references to justification in the *Ordinatio* (July 15, 1140 to January 21, 1142), to the essentially superficial justifications of *De Consecratione* (probably soon after June 11, 1144), and finally to the relatively advanced justifications of *De Administratione* (probably around January 1150 to late September 1150), the tendency in Suger's writings is one of ever increasing justification. But it was only in *De Administratione* that Suger attempted to express his most important nontraditional justification, that of art as a spiritual aid to the monk, and then in a way which for the most part was dependent on the recording of already written inscriptions or on concepts inherent in already exist-

ing artworks. That is, the most undiluted source of this justification from the body of information from St-Denis is in certain of the artworks themselves, not in Suger's account, which is one step removed. Given the dependency of *De Administratione* on this already existing, most important justification and on Suger's general lack of facility in its expression, it seems apparent that he was not directly and personally responsible for its working out.

But if Suger was personally unable to respond to the nontraditional challenges of the reformers himself, then he had to get someone who could. In the same way that he sought outside artists and craftsmen, so it seems that he also sought the advice of perhaps the greatest theologian in Europe at that time, Hugh of St-Victor, a proponent of the intellectual/spiritual use of religious art who was at the same time of strategic value in that he was acceptable to reform circles.[1] While it may be that Hugh's commentary on *The Celestial Hierarchy* suggested to Suger his defense of external materialism on the basis of Pseudo-Dionysian thought, Hugh himself does not seem to have been directly and personally responsible for the exaggerated use of Pseudo-Dionysius in this particular justification. However, the evidence does suggest that his was the thinking behind that of an art accessible only to the *litterati*. Hugh's theology was one which, while tinted with Pseudo-Dionysian thought, was fundamentally Augustinian. And it was Augustinian Christology and exegetical method that, with an element of Pseudo-Dionysianism, were apparently refracted through Hugh to form the conceptual bases of the west central portal and the Allegorical Window, two of the most central artworks of the program. This is not to say that the program was directed by Hugh, only that he seems to have been a close advisor to Suger concerning certain crucial aspects of it. His role in the determination of certain specific iconographical schemes is probably distinct from any overall reasons for the choice of those schemes. That is, the west portal or any of the other artworks at St-Denis are not illustrations of Hugh's writings, but rather his writings are a relatively complex indicator of his role in the determination of various aspects of the art program in that they relate his specific approach to the general subjects presented, and so explain that which is uncommon in their appearance there.

While he may have been directly or indirectly responsible for much of the originality, clarity, organization, geometry, references to Pseudo-Dionysian mysticism, and use of complex exegesis, Suger—who, to paraphrase William of St-Denis, knew how to get things done and get them done right—was probably always the dominant personality. The importance of Suger was not so much as an innovator per se, but rather as a compiler of the thoughts and innovations of others. His contribution lies in the orchestration of the various components of St-Denis into a relatively coherent justification of art, something which was necessary or at least desirable for much of the art of the following period, while at the same time intensifying its visual effectiveness.

The claim of the art of St-Denis as a specifically monastic art was contradicted by its purposefully double function. It was an art for both the literate and the illiterate, the monk and the pilgrim: that which was not understood by the illiterate acted as part of a sensory saturation of the holy place in undisguised disallowance of the tenets of artistic asceticism, and as a spur to the pilgrimage economy objected to by reformers. It was along the lines of sensory saturation that Suger strove to increase the area of the windows of St-Denis, replacing the Romanesque mural both physically and in regard to visual effect. He did this by taking the preexisting elements of the stained glass window and of the skeletal system, and pushing them to the limits: the ambulatory chapel windows of St-Denis being around three times the height of the ambulatory chapel windows of Santiago, and almost three and a half times closer to the viewer, an astonishingly dramatic increase in the viewer's field of vision. Thus the architectural aesthetic of St-Denis was primarily the result, not the cause, of a sensory saturation of the holy place using the most effective artwork at Suger's disposal, the stained glass window. The desire for sensory saturation was not new, in this Suger only continued the previous traditions of the Romanesque. What was new was the determination and ingenuity with which that desire was pursued.

And so we see that artistic change at St-Denis involved something considerably different than has been previously suggested. On the one hand, Suger was not "free" by 1127 to do whatever he pleased artistically as Panofsky claimed; his writings were not pri-

marily directed against the Cistercians; they were not primarily the result of a will to self-perpetuation; and Pseudo-Dionysian light mysticism was not a primary influence in the origins of Gothic. On the other hand, von Simson's idea that Suger's program was somehow in conscious opposition to Romanesque is no more correct; nor is the idea that the program was compatible with Bernard's aesthetic views; that Bernard would not have objected to the program's solicitation of pilgrims; that imagery now occupied a less conspicuous place in the religious experience; or that it was Pseudo-Dionysian light mysticism that had brought about the architectural innovations of St-Denis.

However, von Simson was very much correct when he noted that although St-Denis was the prototype of the Gothic cathedrals, all of the major elements of Gothic architecture were already in existence by the time Suger began his rebuilding of that church; that it was not so much the technical components of Gothic that defined its appearance at this moment as it was the conceptual components and the relation between the technical and the conceptual, the whole being the expression of some new religious experience; and that on the artistic level, this was effected through the replacement of the Romanesque mural with the stained glass window.

Artistic change at St-Denis was the creation of monasticism in that it was the direct outcome of the early twelfth-century controversy over monastic art. Those artworks at St-Denis which were most important to the formation of Gothic—the west central portal and the Allegorical Window, among others—did not just employ the justification of art as a spiritual aid; they were formed by it. However, the reasons for the widespread diffusion of Gothic are not necessarily identical with those of the artistic changes which took place at St-Denis and which are historically specific to St-Denis. The reason for the enthusiastic adoption of this dual-functioning but originally monastic art by the secular cathedrals in an age when the broad social importance of monasticism was on the decline must be investigated on its own terms.[2] At St-Denis, the origins of artistic change are to be found in the pressing issues of the day. They were not primarily the result of the desire for a particular aesthetic expression.[3] Certainly, with Gothic, architecture

74

had become a visually expressive force like never before in medieval art. But Suger's immediate concern was the justification of a lavish art program and that program's forceful presentation. Its aesthetic expression was secondary. In fact, one could say that Suger's aesthetics were the aesthetics of excess—and that it was this aesthetic that led to the provision of the greatest possible amount of area for imagery in the visually most effective means possible: the Gothic stained glass window.

Suger's art program was a synthesis in its form, in that most of its major elements—architectural structure, stained glass, the use of typology, and so on—were preexisting and were brought together at St-Denis to make a coherent whole. It was a synthesis in the sense of function in that its art attempted to address itself in a complex way both "to God and to man," and to the two basic segments of society according to monastic ideology, that of the monk and the nonmonk.[4] But most importantly, it was a synthesis in the sense of its very historical existence. The evidence suggests that without the pressures of artistic asceticism and the early twelfth-century controversy over art, Suger would have undertaken a thoroughly conventional, if lavish, art program. But if Suger was confronted with the challenge of artistic asceticism in the first years of his abbacy—during the time that he was contemplating the shape that his art program for St-Denis would take—by the time that Bernard of Clairvaux himself attended the consecration ceremony for the east end he had developed a complex system of claims to justify that program.[5] It seems that it was largely the pressure of the opposition Suger faced, together with the cooperation and innovation of Hugh of St-Victor and some unknown architectural master—rather than Pseudo-Dionysian light mysticism—that provided the major stimulus toward the meaning and the means of Suger's program. Artistic change at St-Denis was an attempt to claim a middle-ground solution to the question of an acceptable monastic art, and at the same time retain and even increase the previous level of the sensory saturation of the holy place.

NOTES

Introduction

1. Suger, *Vie de Louis VI* 32, pp. 262, 264. I call the visit official because Suger considered it official, describing the papal Easter visit as the custom when a pope was in Gaul; Suger, *De Adm* 32, p. 58.

2. On the history of St-Denis, see Félibien 1706; Crosby 1942; Crosby 1987; von Simson 1974; and various articles in Gerson 1986b. On Suger, see Cartellieri 1898; and various articles in Gerson 1986b, including John F. Benton, "Suger's Life and Personality," 3–15.

3. *Vita Prima* 1:25, PL 185:241; cf. Deut. 32:10.

4. According to *Vita Prima* 2:6, PL 185:272, Innocent visited Clairvaux after his meeting at Liège, Mar. 22–Apr. 1, 1131, with Emperor Lothair III. I call this an unofficial visit because the text explicitly states that Innocent personally wished to visit Clairvaux. The events that took place at St-Denis described here occurred on Apr. 15 and 19, 1131; Suger, *Vie de Louis VI* 32, p. 263. However, Elphège Vacandard believes on the basis of papal documents dated Apr. 12–13 at Laon that the chronology of the *Vita Prima* account is confused and that the visit actually took place shortly after the visit to St-Denis; Vacandard 1902:v.1:312–13.

5. For some contemporary examples of the programmatic exclusion of various art forms, cf. the case of Odo of Tournai in Hermannus of St-Martin, *De Restauracione Abbatiae S Martini Toracensis* 66, PL 180:90; or the Carthusian customary of 1127 which probably reflects earlier practice, Guigues de Châtel, *Consuetudines Carthusienses* 40, PL 153:717–19.

6. Statutes 10 and 20, pp. 15, 17. The Cistercian legislation refers to what Joseph Braun would have called *vasa sacra* and *vasa non sacra*; *Das christliche Altargerät in seinem Sein und in seiner Entwicklung* (Munich, 1932), 2. It does not specifically mention reliquaries, although theoretically they would have been covered. The term "liturgical art," as I use it, is inclusive of all three of these types of art. For a discussion of this legislation and the early recognition of the artistic asceticism of the Cistercians, see Rudolph 1987:1–2.

7. Panofsky 1979:11, 14–16. Edgar de Bruyne, *Etudes d'esthétique médiévale* (Bruges, 1946), v.2:141, and Paul Frankl, *The Gothic: Literary Sources and Interpretation* (Princeton, 1960), 22, also saw Suger's writings as in response to Bernard.

8. Panofsky 1979:26–27, 164, 170, 188. Crosby 1942:16, 16n.37, thought

that *De Consecratione* was directed primarily at certain monks of St-Denis who were not anxious to carry out the building project. The actual stones of the church were considered sacred because it was said that Christ had personally consecrated the church which was believed to have been built by Dagobert I (623–639); however, the church which was actually standing at this time was the Carolingian church of Abbot Fulrad (dedicated 775); *De Cons* 4, p. 100; *De Adm* 25, 29, pp. 44, 50.

9. Panofsky 1979:27–28.

10. Panofsky 1979:18–25, 29. Put as briefly as possible, the patron saint of St-Denis was the person whose relics were venerated there: a third-century missionary and the first bishop of Paris, Dionysius (Denis in French, Dionysius in Latin and in English historical usage). Over the years, he became confused with the same Dionysius mentioned by Paul in Acts 17:34 (first century), who was known as Dionysius the Areopagite and identified elsewhere as the first bishop of Athens. The problem was further compounded when in the eighth century the Byzantine emperor Michael the Stammerer gave the Carolingian emperor Louis the Pious a Greek copy of the mystical writings of another Dionysius—this time an early sixth-century mystic, probably of Syrian origin. The writings were immediately attributed to the patron saint of the abbey and after an unsuccessful translation by Abbot Hilduin of St-Denis were adequately translated by Erigena. As if this were not enough, Abelard, when he was for a short time a monk of St-Denis in the years immediately previous to the abbacy of Suger, earned the disfavor of the monastery and Suger by suggesting that the patron saint of the abbey was not the Dionysius who was the first bishop of Athens, but rather the Dionysius who was the first bishop of Corinth (ca. 170), and so not the Areopagite who was the disciple of Paul and who was believed to be the great mystic.

11. Panofsky 1979:18, 24–25, 29.

12. Panofsky 1979:29–36. Although he gave it less emphasis than the personal, Panofsky recognized Suger's adherence to the traditional practice of art for the honor of God; Panofsky 1979:15–16. He also saw psychological reasons as the basis for Bernard's rejection of religious art, reasons which I believe I have shown to be misleading; Conrad Rudolph, "Bernard of Clairvaux's *Apologia* as a Description of Cluny and the Controversy over Monastic Art," *Gesta* 27 (1988): 125–32.

13. Von Simson 1974:8–58, 63–90, 105–12, 135–41. Arthur Kingsley Porter, *Romanesque Sculpture of the Pilgrimage Roads* (Boston, 1923), v.1:222–24.

14. Von Simson 1974:123, 111, 113; cf. Christe 1966:9–10. Grodecki thought that Suger's art program was a reaction to Cistercian austerity; "Suger et l'architecture monastique," *Bulletin des relations artistiques France-*

Allemagne, special number, May, 1951; I have been unable to locate this article; referred to by von Simson 1974:112n.70.

15. Von Simson 1974:112; as did Félibien 1706:175.

16. Von Simson 1974:61, 62, 98, 111, 113. The identification of Romanesque with Cluny is von Simson's.

17. Von Simson 1974:xv, 62. This has also been recognized by Bony 1983:7, 45–46.

18. Von Simson 1974:xix–xx, 3–5, 10, 61–62, 106, 120–21. Von Simson has not modified his views on the subject; von Simson:1988, 35–36. For a considerably less restrained critique especially of Panofsky but also of von Simson and Crosby, see Kidson 1987. Kidson's article came to my attention only when this book had long been finished. While our views of the role of Pseudo-Dionysian mysticism at St-Denis do not agree on certain crucial points, they do tend to support each other in regard to the abovementioned authors.

CHAPTER 1

1. The old traditional Benedictine reform movement was that reform most commonly associated with the abbey of Cluny, although many other movements with varying degrees of relation to Cluny were also active. The movement was most effective during the tenth and eleventh centuries. The Cistercians, that order most commonly associated with the new reform, were also Benedictine, although that term is not normally applied to them. On the crisis of prosperity, see Jean Leclercq, "The Monastic Crisis of the Eleventh and Twelfth Centuries," in *Cluniac Monasticism in the Central Middle Ages*, ed. Noreen Hunt (London, 1971), 217–37, esp. 222.

2. Luxury, as I use the term, is anything involving a higher degree of sense perception than required in average use. Materialism and cost, which are not necessarily dependent, tend to be associated with it.

3. Born 1090; novice 1113; abbot 1115; died 1153. The standard modern biography is Vacandard 1902. Works are also in progress by Christopher Holdsworth and Jean Leclercq. The date of 1112 for the entry of Bernard into the novitiate was probably falsified during his own life for political reasons; see Adriaan Bredero, "Etudes sur la 'Vita Prima' de saint Bernard," *Analecta Sacri Ordinis Cisterciensis* 17 (1961): 62, 70–71. Bredero's thesis is not accepted by all.

4. For example, Statutes 1, 4–10, 13–15, 20–27, pp. 13–19. Cf. *Exordium Parvum* 15, in *Les plus anciens textes de Cîteaux*, ed. Jean de la Croix Bouton and Jean-Baptiste Van Damme (Achel, 1974), 77–78. However, there was a tendency not to follow their own regulations. See Louis Lekai, "Ideals

and Reality in Early Cistercian Life and Legislation," in *Cistercian Ideals and Reality*, ed. J. Sommerfeldt, Cistercian Studies Series 60 (Kalamazoo, Mich., 1978), 4–29.

5. For example, despite its extensive agricultural holdings, Cluny was in an almost chronic state of financial uncertainty at this time. See George Duby, "Economie domaniale et écomomie monétaire: le budget de l'abbaye de Cluny entre 1080 et 1155," *Annales* 7 (1952): 155–71.

6. This attitude of relative open-mindedness comes through clearly in Orderic Vitalis's accounts of various new ascetic orders; *Ecclesiastical History* 8:26, v.4:310–26. However, cf. *Ecclesiastical History* 8:27, 13:13, v.4:332–34, v.6:426. Both Suger and Peter the Venerable of Cluny are even known to have given financial support to Cistercian houses. On Suger, see Félibien 1706:196; cf. Bernard of Clairvaux, *Ep* 379, v.8:343. On Peter the Venerable, see Bernard of Clairvaux, *Ep* 277, 389, v.8:189–90, 357. And on the support of Abbot Pons of Cluny for the Cistercians, see Herbert Cowdrey, "Pontius of Cluny," *Studi Gregoriani* 11 (1978): 259n.4. Hugh of Amiens, one of Suger's friends who consecrated altars in both the west and east ends of St-Denis, describes how before the *Apologia* he was always eager to read Bernard's latest works; *Riposte*, p. 309. The attribution of the *Riposte* to Hugh of Amiens is not accepted by all. On Hugh's participation at St-Denis, see Suger, *Ord*, p. 132; *De Cons* 4, 7, pp. 96, 118; *De Adm* 26, p. 44. Cf. *Ord*, p. 130; *De Cons* 6, p. 112; *De Adm* 33A, p. 68. The chapters of the Benedictine abbots of the province of Reims, particularly those which met in 1131 and 1132, were extremely sympathetic to the new orders. Cf. the letter of Cardinal Matthew of Albano to the abbots and their response: Matthew of Albano, *Ep*, pp. 320–33; *Responsio Abbatum*, pp. 334–50.

7. Bernard of Clairvaux, *Ep* 78, v.7:201–10. Bernard's references to Suger's changes are vague and spread throughout this letter; but see esp. *Ep* 78:3, 13, v.7:203, 210: "In other respects you have satisfied the critics, and even gone further so that we should rightly praise your efforts (*et adiecisti quod merito collaudemus*). . . . In heaven, the conversion of one sinner arouses great joy: what about an entire congregation, and what about one such as this? [13] . . . to begin advances one not at all, if it does not happen that one perseveres." The latter passage is more complex than I suggest here.

8. The implication that Bernard was the impetus to Suger's changes is conveyed through tone, and runs throughout the letter. Bernard objects to Suger's retinue: *Ep* 78:3, v.7:203: "There was only one thing (*solumque ac totum*) that bothered me (*nos*), namely that manner and splendor of yours when you appeared in public. . . ." Bernard twice describes Suger's

change as "unexpected": *Ep* 78:1, 3, v.7:201, 203, *"subita mutatione," "repentina immutatio."*

Given Bernard's criticism of Suger's excessive retinue in *Ep* 78:3 and other examples of Suger's attraction to this form of luxury (for example, Suger, *Vie de Louis VI* 10, 32, pp. 62, 262–64), it seems clear that Bernard's earlier reference to the same activity in *Apologia* 27, v.3:103–4 was made with Suger foremost in mind, the short distance of four leagues that certain abbots could not travel without taking all their belongings with them being suggestive of the close proximity of St-Denis to Paris.

9. On the retinue, see esp. Bernard of Clairvaux, *Ep* 78:3, v.7:203: "There was only one thing (*solumque ac totum*) that bothered me (*nos*), namely that manner and splendor of yours when you appeared in public, which was clearly a little too haughty. If you had put aside [your] arrogance and changed [your] manner, you would have easily been able to quiet the indignation of all." On the opening up of the monastery, see Bernard of Clairvaux, *Ep* 78:4, v.7:203–4: "From ancient times your monastery (*locus*) was noble, and was of royal dignity. It was accustomed to attend zealously the business of the palace and of the armies of the kings. Without hesitation or deception the things [which were Caesar's] were rendered to Caesar, but the things which were God's were not payed with equal fidelity. . . . They say that the very cloister of the monastery was frequently crowded with soldiers, that it was continually disturbed with commercial activities, that it resounded with altercations, and that it was at times accessible to women. . . . The Savior rebuked certain persons because they made the house of prayer into a den of thieves. He will, therefore, undoubtedly commend him . . . by whose enthusiasm and industry what seemed a workshop of Vulcan has been surrendered to heavenly endeavors, indeed, God's habitation has been returned to him, and restored from a synagogue of Satan to that which it was before."

The irregularity concerning the cloister seems to have been the ultimate cause of Bernard's description of the monastery as "a synagogue of Satan," the reference to Apoc. 2:9 implying the giving of priority to temporal affairs over the monastic rejection of the temporal: "I know your tribulations and your poverty—although you are [spiritually] rich—and [I know] the blasphemies by those who say that they are Jews and are not, but are a synagogue of Satan."

All biblical references here are to the Vulgate; I normally translate passages from the Bible myself, since modern translations are not from the Vulgate and since the Douai translation is antiquated. According to *Ep* 78:5, v.7:204, it seems that an outside school was also conducted in the cloister.

10. Suger, *Testamentum*, ed. Lecoy, pp. 333–41; *Ord*, pp. 128–32; a charter of ca. 1130, ed. Lecoy, pp. 326–31; Constable 1986:20; John F. Benton, "Suger's Life and Personality," in Gerson 1986b:7; Niels Rasmussen, "The Liturgy at Saint-Denis: A Preliminary Study," in Gerson 1986b:44. On the upgrading of the monks' meals, see Suger, *Ord*, pp. 122–28, 132; a charter of ca. 1130, ed. Lecoy, p. 328. For the most complete account of these changes, see Constable 1986:18–20; cf. also Panofsky 1979:10–15; and Félibien 1706:157–62. Although he does not elaborate, Bautier 1981:69n.2 believes that "there was no reform at St-Denis." For Suger's own characterization of the changes, see his *Vie de Louis VI* 27, p. 212, where after listing the major accomplishments of his abbacy, including the building program, he writes: "the most important and most freely given thing, indeed, the greatest privilege [God's] pity showed [was] that he completely reformed the holy order of his holy Church in that very place for the honor of the saints, indeed, for his [own honor], [and] he peacefully established without scandal and without the disturbance of the brothers— although they were not [so] accustomed—the way of life of holy religion by which one comes to delight in God."

11. William of St-Denis, *Dialogus*, p. 86. John of Salisbury, *Historia* 7–9, 12, pp. 14, 15–16, 21, 26–27.

12. For Bernard's support of the reforms of the traditional Benedictine abbots of the province of Reims, see *Ep* 91, v.7:239–41. Cf. the letter Matthew of Albano wrote to the same abbots, and their response to him: Matthew of Albano, *Ep*, pp. 320–33; and *Responsio Abbatum*, pp. 334–50. Some of the reforms objected to by Matthew involved the shortening of the psalmody; a greater imposition of silence; restrictions on liturgical vestments, candles, and so on in processions; and reduction of the use of liturgical art.

13. Cf. the reply attributed to Hugh of Amiens, *Riposte*; Peter the Venerable, *The Letters of Peter the Venerable*, ed. Giles Constable (Cambridge, Mass., 1967) Letter 28, v.1:52–101; Matthew of Albano, *Ep*; Bernard of Clairvaux, *Ep* 91:4, v.7:240–41; Rupert of Deutz, in John Van Engen, *Rupert of Deutz* (Berkeley, 1983), 299–334.

14. Bernard's letter to Suger closes with a warning to Suger that he do what he can to get rid of Etienne de Garlande; *Ep* 78:13, v.7:210. Bautier suggests that this warning was something which Suger very much desired, indeed, even sought; Bautier 1981:66, 67, 69, 69n.2. However, I do not believe, nor does Bautier imply, that Suger's and Bernard's alliance was based on anything more than mutual expediency.

Bernard also gained a useful political ally for future political attacks; John of Salisbury, *Historia* 8, pp. 15–16 implies that Suger aided Bernard

in his attack on Gilbert de la Porée through "a desire to propitiate the abbot."

15. Cf. Bernard of Clairvaux, *Ep* 91:4, v.7:240, where Bernard mentions having avoided criticizing the conservative faction for some time prior to the autumn of 1132.

16. Suger, *Vie de Louis VI* 27, p. 212—"*plene reformavit*"; Bernard of Clairvaux, *Ep* 78:1, 3, v.7:201, 203—"*subita mutatione*," "*repentina immutatio*." The exact wording of the letter sent by Bernard to Suger in 1127 congratulating him on his recent changes at St-Denis suggests that if any pressure had been applied by Bernard on Suger, it had been indirect only, *Ep* 78:3, v.7:203.

17. Suger, *Vie de Louis VI* 27, p. 212.

CHAPTER 2

1. I recognize that this is a simplification and that there were exceptions. However, I would like to distinguish between straightforward theological presentations in art and an art that may be described as more specifically monastic: a complex theological subject is by no means necessarily monastic. Also, I exclude book illumination from consideration here since this was not an area taken up by Suger in his writings, nor of which we have any exceptional examples from St-Denis; see Harvey Stahl, "The Problem of Manuscript Painting at Saint-Denis During the Abbacy of Suger," in Gerson 1986b:163–81. I also recognize that the question of the justification of art before the early twelfth century is more complex than is presented here.

2. For a contemporary expression of the distinction between doctrine and tradition, see Guibert de Nogent, *De Pignoribus Sanctorum* 1:1, PL 156:612–13. Secular religious art is that art used by the secular Church (that part of the Church which was nonmonastic).

3. Gregory the Great, *Ep* 9:209, 11:10, pp. 768, 873–75 (*Ep* 9:105, 11:13 in PL 77:1027–28, 1128–30). Gregory made no mention of art for the honor of God in these letters, or in the letter now designated appendix 10 in pp. 1104–11 which is spurious (*Ep* 9:52 in PL 77:982–91).

4. For example, see Gilbert Crispin, *Disputatio Iudei et Christiani* 153–61, in *The Works of Gilbert Crispin, Abbot of Westminster*, ed. A. S. Abulafia, Auctores Britannici Medii Aevi 8 (London, 1986), 50–53. On the use of art as decoration, see *Libri Carolini*, pref., 2:31, 3:16, 4:3, PL 98:1002, 1112, 1147, 1188. God was also honored through the honor paid to the saints through art.

5. "*Cuius [Christ's] imago ut affectuose, ad celebrandam Dominice passionis*

memoriam, sculptili sive fictili formetur opere, sancta et universalis recipit eccle-sia. Sanctorum autem memoriam humanis visibus vel veridica libri scriptura, vel imagines umbrose coloratis parietibus depicte tantum debent ostendere. Nam sanc-torum statuas, nisi ob antiquam abusionem atque invincibilem ingenitamque idi-otarum consuetudinem, nulla ratione patimur," Bernard of Angers, *Liber Mir-aculorum* 1:13, p. 47. Although Bernard of Angers later changed his personal view toward image-reliquaries and became a monk at Ste-Foi, his discussion is presented expressly as Church tradition. Again, manuscript illumination will not be taken up in this study since it was not part of Suger's program of justifications.

6. See n. 5 of the Introduction.

7. Cistercian art legislation had created something of a sensation; see, for example, the comments of William of Malmesbury in Rudolph 1987:1–2. The date of 1115–1119 is tentative until more conclusive proof is offered.

8. On this legislation in general, see Rudolph 1987. A fistula is essen-tially a drinking straw for the element of the wine in the Eucharist.

9. Jerome, *Contra Vigilantium* 15, PL 23:351 (or 367 in the 1845 ed.): *"Monachus autem non doctoris habet, sed plangentis officium,"* a passage cur-rently cited in regard to monastic assumption of pastoral care. See, for example, Bernard of Clairvaux, *Ep* 89:2, v.7:236: "the function [of the monk] is not to teach, but rather to lament (*officium* [*monachi*] *non est docere, sed lugere*)."

10. The exact date of the *Apologia* is not yet beyond question. I base my date on the work of Damien Van den Eynde, "Les premiers écrits de S Bernard," *Recueil d'études sur saint Bernard et ses écrits*, ed. J. Leclercq (Rome, 1969), v.3:395–405. On the *Apologia* and the early twelfth-century controversy over art, see Rudolph 1991.

11. That the passage on art in the *Apologia* was not specifically directed at Suger is suggested by the fact that in his letter to Suger of 1127, Bernard insisted that the "only thing and all that disturbed" him was the luxury of Suger's retinue; Bernard of Clairvaux, *Ep* 78:3, v.7:203. All references to art from the *Apologia* cited here are from *Apologia* 27–29, v.3:103–6. Schol-ars are agreed that although Bernard's censure of luxury in abbatial reti-nues was meant as a general criticism, he was referring to Suger in partic-ular (*Apol* 27).

12. See Matthew of Albano, *Ep*, pp. 331–32; and the reply to Matthew by the abbots, *Responsio Abbatum*, p. 348. The abbots note that the beauty of the house of God (Ps. 25:8) is interior. The importance of the document as far as art is concerned lies in the fact that a public position was taken. It only suggests a consensus on a restrictive opinion on art among the

abbots; it does not mean that all the abbots of the synod felt this way, or even that the abbots who signed were actually doing away with art.

CHAPTER 3

1. It does not seem likely that Suger had been trying to disguise an original master plan for the complete rebuilding of St-Denis as a series of spontaneous undertakings in order to more easily gain support at each stage of the project. Cf. his concern with concordance and especially the repair of the columns: *De Cons* 2, 3, 4, pp. 90, 94, 100. And cf. the legal provision for funding for the continuation of the west end, east end, and towers in the *Ord*, p. 134; and repeated in *De Cons* 4, p. 102.

Suger's art program involved the repair and repainting of the old nave, a rebuilding and extension of the west and east ends, the installation of stained glass windows (especially in the east end), and the commissioning of numerous works of liturgical art.

2. Suger conceived of the repair and repainting of the nave by 1106 at the latest: *De Adm* 24, p. 42; Cartellieri 1898:4. The Carolingian church had been painted: Crosby 1987:80–81. On repair and repainting of the nave as beginning from 1122 to 1125: *De Adm* 24, p. 42. Suger got the idea to renovate the west end while working on the nave: *De Adm* 25, pp. 42–44. That this idea occurred by 1125: see the charter of 1125 in ed. Lecoy, p. 320, which states: "*quod ipsi* [the inhabitants of the town of St-Denis and certain others from St-Marcel], *ad introitum monasterii Beati Dionysii renovandum et decorandum ducentas libras . . . contulerunt.*" Crosby, following Ernst Gall, *Die gotische Baukunst in Frankreich und Deutschland* (Leipzig, 1925), v.1:102, did not see *monasterium* as referring to the west end, although Panofsky 1979:150 and von Simson 1974:91–92 did; instead, he saw it as referring to a gate in the circuit wall of the monastery; *L'Abbaye royale de Saint-Denis* (Paris, 1953), 32; Crosby 1987:114, 124. It is well known that the word *monasterium* was often used to describe the main church of a monastery as well as the entire monastery; cf. Panofsky 1979:148–49. That this was the west end of the church rather than some more utilitarian entrance to the monastery proper is suggested by the fact that the considerable amount of two hundred pounds was contributed toward this undertaking, the same amount used by Suger to keep an unusually large construction crew complete with artists working "summer and winter" for an entire year: this indicates that some sort of major work was being undertaken; *De Cons* 4, 5, p. 102, 104; and see Panofsky 1979:150 concerning the value of the two hundred pounds funding relative to the cost of urban dwellings. There was also new revenue available

from the concession in favor of St-Denis concerning the Lendit in 1124. Two hundred pounds was only what the charter called for; it was not necessarily the maximum limit of the budget. Furthermore, the same word that is used to indicate the entrance in the charter, *introitus*, is used by Suger four times in *De Administratione* to indicate the entrance of the west end of the abbey church: *De Adm* 25, 34, pp. 44, 72.

3. On the renovation and decoration, see the charter of 1125 in ed. Lecoy, p. 320, quoted above. On the augmentation, see Suger's *Testamentum* of 1137, ed. Lecoy, p. 336: "*in novi et magni aedificii ecclesiae augmentatione. . . .*" Suger also used the word *augmentandum* in his description of how the decision to rebuild the west end came about in *De Adm* 25, p. 42; and *augmentacionem* in summarizing his major abbatial accomplishments in *Vie de Louis VI* 27, p. 212. On the need for space as a major reason in rebuilding, see *Ord*, p. 134; *De Cons* 2, 4, pp. 86–88, 98; *De Adm* 25, pp. 42–44.

4. *Ord*, p. 134; *De Cons* 4, p. 98; *De Adm* 28, p. 48.

5. The confident tone of the *Testamentum* (June 17, 1137) suggests that the new quarry near Pontoise, which provided good-quality building stone for the rebuilding of St-Denis, was being worked by that time. Cf. *De Cons* 2, pp. 90–92.

6. *Ord*, p. 134; *De Cons* 4, p. 98; *De Adm* 28, p. 48.

7. See also the charter of Mar. 15, 1125, ed. Lecoy, p. 320; Suger's *Testamentum* of June 17, 1137, ed. Lecoy, p. 336; and the passage on art in Suger, *Vie de Louis VI* 27, p. 212.

8. Panofsky 1979:141.

9. For all of Panofsky's dating, Panofsky 1979:142–43. *Ordinatio* had been previously dated to ca. 1140 by Lecoy, p. 349; and to 1140, after July 14, by Cartellieri 1898:140–41.

10. Lecoy 1867:xi; the logic is Lecoy's, who, however, is not as precise as Panofsky in articulating it. The date of 1143 given by Lecoy is apparently an oversight for 1144.

11. Cartellieri 1898:81n.4. On the date of Evrard's death, see below. Lecoy had previously dated *De Administratione* to probably 1145–1147; Lecoy 1867:ix.

12. Transepts: *De Adm* 28, p. 50. Nave: *De Adm* 29, pp. 50–52. Continued work on towers and completion of one tower: *De Adm* 29, pp. 50–52. *De Cons* only discusses postponing the towers and the financing of their later completion. It also indicates that neither tower had been finished before work on the east end was begun: *De Cons* 4, pp. 98, 102. It seems clear that *retraxit* (*De Adm* 29, p. 50) refers to Suger's being pulled away from the completion of the towers again, and that work was stopped on

the one unfinished tower—i.e., the expert administrator Suger is follow-
ing the same successful strategy of resources that allowed the rapid con-
struction of the east end.

13. "It will be completed either through us or through those whom the
Lord shall elect . . ."; *De Adm* 29, p. 52. Archaeological remains confirm
that work had begun, although it seems that the extent of the reconstruc-
tion of the transepts and nave was not very great; Crosby 1987:267–77,
339–52. Although Suger provided for the continuance of this work (*De
Adm* 29, p. 52), state expenses incurred during his regency (William of St-
Denis, *Vita Sugerii* 3:3, ed. Lecoy, p. 395) may have slowed it down con-
siderably in relation to the rapid construction of the east end.

14. *De Adm* 32, pp. 58–60; Philippe Verdier, "La grand croix de l'abbé
Suger à Saint-Denis," *Cahiers de civilisation médiévale Xe–XIIe siècles* 13
(1970): 2.

15. *De Adm* 14, ed. Lecoy, p. 174. Cartellieri 1898:81n.4 dates Evrard's
death to the end of 1148 or the beginning of 1149. However, this was
probably an error for the end of 1147 or the beginning of 1148 since Evrard
died in the horribly mismanaged journey of the Crusaders from Laodicea
to Adalia, which took place in January 1148; the circumstances of Evrard's
death are mentioned by Odo of Deuil, *De Profectione* 6–7, pp. 112–22, esp.
122.

16. *De Adm* 33, p. 64.

17. Odo of Deuil, *De Profectione* 4, pp. 58–66, esp. 64–66. It is clear from
Odo's description of certain aspects of Constantinople that he was one of
those allowed to enter the city. Suger's reference to Bishop Hugh of Laon
is problematic, but has little bearing on the argument made here in any
case; cf. Panofsky 1979:193.

18. William of St-Denis, *Vita Sugerii* 3:9, 3:11, ed. Lecoy, pp. 400–401,
401–2; *Epistola Encyclica*, ed. Lecoy, p. 407.

19. According to *De Adm* 29, p. 52, some of the windows of the church
were not yet made; so if my hypothesis on the date of *De Administratione*
is correct, some of the windows were not yet made by 1150. Cf. E.A.R.
Brown and M. W. Cothren, "The Twelfth-Century Crusading Window of
the Abbey of Saint-Denis," *Journal of the Warburg and Courtauld Institutes* 49
(1986): 3, 38.

20. On honor: *Ord*, p. 134. Reciprocity: *Ord*, p. 132. Craftsmanship:
Ord, p. 130. Communality: *Ord*, p. 102 (passage repeated in *De Consecra-
tione*). All of these themes are discussed below. Suger's *Testamentum* con-
tains some general references to reciprocity and communality, although
not specifically applied to art. In it Suger expresses the desire to avoid
seeking empty glory for himself; *Testamentum*, ed. Lecoy, pp. 336–37.

21. The following lists only the more interesting references. Honor: *De Cons* 4, p. 98. Reciprocity: *De Cons* 1, 2, 4, 5, 6, pp. 84, 90, 98, 106, 110. Craftsmanship and material: *De Cons* 5, pp. 104, 106. Communality: *De Cons* 4, pp. 98, 102. Encouragement: *De Cons* 2, 2–3, 4, 5, pp. 90, 92–94, 96, 100, 106–8. Spiritual aid: *De Cons* 2, p. 92; cf. *De Cons* 1, 5, 7, pp. 82–84, 104, 120.

22. The issue of communality is not restricted to monasticism.

23. The format and to some degree the aims of *De Administratione* seem to be similar to those in Suger's *Vie de Louis VI*.

24. This is not a complete listing. Honor: *De Adm* 26, 27, 31, 33, 33A, 34A, pp. 46, 54, 62–66, 66, 76, 78 (according to Verdier 1986:160 this inscription may have been interpolated into Suger's original manuscript), 80. Reciprocity: *De Adm* 1, 24, 27, 30, 31, 33, 34A, pp. 40, 42, 46, 52, 54, 64–66, 78 (again, the inscription referred to here may be an interpolation),/ 80. Craftsmanship and material: *De Adm* 27, 32, 33, 34, 34A, pp. 46–48, 58, 60–62, 72, 76–78. Communality: *De Adm* 1, 25, 28, 29, pp. 40, 42–44, 48, 50–52. Encouragement: *De Adm* 24, 25, 28, 29, 30, 31, 32, pp. 42, 42–44, 48, 50–52, 52, 54, 58–60. Old Testament precedent: *De Adm* 33, pp. 64–66. Spiritual aid: *De Adm* 27, 32, 33, 34, 34A, pp. 46–48, 58, 62–64, 74–76, 80; cf. *De Adm* 31, p. 54.

25. While some of the elements of *De Consecratione* which were not taken up in *De Administratione* may have received less attention or even been dropped in order to avoid some of the duplication that took place, it may also be true that these types of justificative support came to be regarded as conceptually outmoded with *De Administratione*. However, I do not wish to overstate the case.

26. For example, Suger, *Vie de Louis VI* 13, 32, 33, pp. 84, 262–64, 276. Nor are any of Suger's nontraditional justifications found in William of St-Denis' life of Suger, despite William's close association with the abbot.

CHAPTER 4

1. *De Adm* 33, pp. 64–66. The reference to the preference of a "pure heart" to liturgical art is probably ultimately from Chrysostom, *Homiliae in Matthaeum* 50:3, PG 58:508.

2. There were also a number of lesser Old Testament precedents.

3. Suger quoted from Heb. 9:13–14 (Panofsky 1979:15–16, 193), but referred to the entire passage, Heb. 9:1–14.

4. *De Adm* 33, pp. 64–66. Cf. the statement of Idung of Prüfening (after 1153/1155) in which Idung cites the passage from Jerome: "Either we repudiate the gold along with the rest of the superstitions of the Jews, or if

the gold is pleasing, the Jews are pleasing"; Idung, *Dialogus* 1:37, in *Le moine Idung et ses deux ouvrages: "Argumentum super quatuor questionibus" et "Dialogus duorum monachorum"*, ed. R. Huygens, Biblioteca degli "Studi medievali" 11 (Spoleto, 1980), 106; cf. Jerome, *Ep* 52:10, ed. Jérôme Labourt, *Saint Jérôme: Lettres* (Paris, 1949–1963), v.2:186. The references to David in *De Adm* 25, 28, pp. 44, 48, are not specifically justifications of the art program.

5. This justification appears only in the later *De Administratione*. While this may be just a coincidence, it may be that Suger wished to avoid a straightforward claim of Old Testament precedent in the earlier works, but was unsure how to go about it at the time.

6. *De Cons* 3, 5, pp. 92–94, 108. Verdier 1986:160n.10 points out that most of these are divine signs rather than miracles proper.

7. *De Cons* 2, 3, 5, pp. 90, 94–96, 106–8. The provision of mutton for the dedication of the east end is an example of just how far Suger could go in this direction, *De Cons* 5, pp. 108–10.

8. *De Adm* 32, p. 58; and see also below on this story. Cf. *De Adm* 31, p. 54. Divine support in the speed of construction is mentioned in *De Adm* 28, p. 48, but it should be noted that the speed of construction also often represented a claim to supraregional prestige. Cf. Warnke 1979:23.

9. Repair of the old nave: *De Adm* 24, p. 42. West end: *De Adm* 25, pp. 42–44. East end: *De Adm* 28, p. 48. Reconstruction of the nave: *De Adm* 29, pp. 50–52. Liturgical artworks: *De Adm* 30, p. 52. *De Consecratione* refers only to God's inspiration in the decision to retain the stones of the old nave; *De Cons* 4, p. 100. As stated above, more general references to God's help run throughout the works.

10. *De Cons* 1, 5, pp. 84, 106. This is perhaps the most articulate example of a traditional justification. It does not seem to be in response to Bernard's charge that Suger was slow to render to God the things that were God's; *Ep* 78:4, v.7:203.

11. *De Cons* 1, 6, pp. 84, 110.

12. *De Adm* 27, 31, pp. 46, 54. Reciprocity is implied in other public inscriptions.

13. *De Cons* 1, p. 84; and *De Cons* 2, p. 90: "at first expending little we lacked much, afterwards, expending much we lacked nothing at all and even confessed in our abundance, our sufficiency is of God [2 Cor. 3:5]."

14. This is the only miracle-type provision story in *De Administratione* and is primarily and clearly meant to get the best of Bernard. Suger calls it *unum jocosum, sed nobile miraculum*. The "miracle," as other contemporary literature suggests, was that Suger got the better of a Cistercian in a financial transaction; *De Adm* 32, p. 58 makes a point of mentioning that

two of the three monks who came to Suger to sell him a vast quantity of jewels were from Cîteaux and Fontevrault; but any suggestion as to where the third was from, aside from noting that it was a Cistercian monastery, is conspicuous by its absence. Suger also makes a point of noting that the three had received the jewels from Count Thibault IV of Blois, who inherited them from his uncle, King Henry I of England. It seems that it is the same collection of jewels referred to in *Vita Prima* 2:55, PL 185:301–2, part of which had been given to Bernard by Thibault sometime after the destruction of Vitry in 1142, and which Thibault is specified as having received from Henry (this has also been suggested by the editor of the *Vita Prima*). Since the special relationship between Bernard and Thibault was so well known, Suger's "discreet" avoidance of naming Clairvaux would have been understood and appreciated all the more by his contemporaries at the expense of Bernard, who liked to refer to Suger as a "rich abbot"; cf. Bernard of Clairvaux, *Ep* 379, v.8:343.

15. Ovid, *Metamorphoses* 2:5: *materiam superabat opus. De Adm* 33, pp. 60–62. For a discussion of the use of this phrase and a similar one of Pliny's, see chap. 2.2 of Rudolph 1991.

16. William of St-Thierry, to whom the *Apologia* was addressed, wrote a work ca. 1120 that came to be known as the *Anti-Naso* (Naso being the cognomen of Ovid), his *De Natura et Dignitate Amoris*. See Etienne Gilson, *The Mystical Theology of Saint Bernard* (New York, 1940), 9, 200.

17. *De Adm* 27, pp. 46–48. Although the doors are shown to be the artistic centerpiece by the attention given to them by Suger, the conceptual centerpiece is the tympanum.

18. William of St-Denis, *Vita Sugerii* 2:10, ed. Lecoy, p. 392. As described by Leclercq, a *sentenia* may at times be thought of as a particularly monastic convention, a spontaneous statement—even a meditation spoken aloud—summarizing some practical point of monastic life; Leclercq 1974:168–72.

19. *Ord*, pp. 128–32; *De Cons* 2, 7, pp. 86, 116; *De Adm* 25, 32, 33, 33A, 34, 34A, pp. 44, 58, 60, 70, 72, 76. The divine intervention to protect the east end during the storm took place on the anniversary of Dagobert; *De Cons* 5, p. 108. The preponderance of these references are in *De Administratione*. The participation of Louis VII is also mentioned often in the *Ordinatio* and *De Consecratione*, with such specific references noticeably curtailed in *De Administratione*. On Dagobert and Charlemagne as authorities for the emphasis on the Cult of the Dead, see Orderic Vitalis, *Ecclesiastical History* 8:26, v.4:318–20.

20. *De Adm* 26, p. 44. I believe Suger's use of *habilis* in describing this chapel is best translated as "proper" or "suitable," Panofsky's "conven-

ient" not fitting the situation. Gardner has noted a lessening of architectural detail of the upper chapels of the west end in relation to the lower part of the west end, suggesting that it was the result of the less public nature of the chapels; Gardner, 579. Indeed, it seems to have been the specifically monastic function of the chapels that brought such a design decision about, even though in reality the claim was contradicted by the increase in window size for Suger's stained glass windows (cf. Gardner 1984:580n.24, 585; Suger, *De Adm* 34, p. 72; and below).

21. *Ord*, p. 134; *De Cons* 2, p. 86; *De Adm* 25, p. 42. Cf. *De Cons* 2, 4, pp. 89, 98, 100; *De Adm* 28, 31, pp. 48, 56. Cf. Rodulfus Glaber, *Historiarum Sui Temporis* 3:4, PL 142:651, where the unnecessary rebuilding of churches is mentioned, but not in a negative way. Cf. Warnke 1979:21. Peter Damian severely criticized Richard of St-Vanne for his excess in architecture; Peter Damian, *Ep* bk.8:2, PL 144:465. The need for repair could also be used and misused like the need to rebuild. It should be remembered that the west end rebuilding at St-Denis began as a simple renovation. The need for repair was also repeatedly cited in the area of liturgical art by Suger.

22. *Miraculorum Quorundam Sancti Hugonis Relatio*, ed. M. Marrier and A. Duchesne, *Bibliotheca Cluniacensis* (Paris, 1614), 458.

23. *Vita Prima* 2:29–30, PL 185:284–85.

24. These references to communal agreement may have been made for economic as well as political reasons; cf. the evidence of an earlier period at St-Denis in Bernhardt 1987:69–70. St-Denis (around 111m) was approximately 8m or 7.7% (around the length of the west bay of the narthex) longer than Clairvaux II (around 103m); these measurements are not exact.

25. *De Adm* 24, 25, 31, 32, 33, 34, pp. 42, 44, 54, 56, 58, 64, 72–74. Cf. *De Adm* 25, 27, pp. 44, 46; *De Cons* 2, p. 90; Warnke 1979:13–27, 94–100. I borrow the term "supraregional" from Warnke. There may have been an element of rivalry with Cluny in Suger's desire to bring columns from Rome.

CHAPTER 5

1. For example, Gerson 1986a:194; Michel Bur, "A Note on Suger's Understanding of Political Power," in Gerson 1986b:75; von Simson 1974:131; Zinn 1986:33; Robert W. Hanning, "Suger's Literary Style and Vision," in Gerson 1986b:145. Suger's prose denies the importance of logical sequence, ibid., p. 148.

2. Von Simson 1974:115n.73, 120–21. Von Simson is criticized by Zinn

1986:33. Von Simson gives more attention to Hugh, although without any significant detail, in a retrospective review of his earlier book; von Simson 1988:36. Of the references to Hugh dealing with the symbolism of windows cited by von Simson (1979:120n.86, n.87), the first is not by Hugh, but by Richard of St-Victor, and the rest do not actually refer to windows. See also Philippe Verdier, "Réflexions sur l'esthétique de Suger: A propos de quelques passages du *De administratione*," *Etudes de civilisation médiévale (IXe–XIIe siècles): Mélanges offerts à Edmond-René Labande* (Poitiers, 1975), 707; Christe 1966:7–9; and Bony 1986:135.

3. Zinn 1986:33–37. Zinn also tries in his 1986 study to draw a connection between the imagery of the high altar and some of Richard of St-Victor's works, although he believes that Richard came to St-Victor only ca. 1155 or around four years after Suger's death and fourteen years after the imagery's installation; Grover A. Zinn, *Richard of St-Victor* (New York, 1979), 3.

4. All that is known about the iconography of the doors is that the *passio Salvatoris et resurrectio vel ascensio* was represented on them, and that Suger had portrayed himself in an Emmaus scene; *De Adm* 27, pp. 46–48; on the portrait of Suger in the Emmaus scene, see S. G. Millet, *Le Trésor sacré ou inventaire des sainctes reliques . . . de S Denis en France*, 2d ed. (Paris, 1638), 26. Gerson believes that the word *vel* indicates that the words *resurrectio* and *ascensio* refer to cycles, not individual scenes, Gerson 1970:102n.3.

5. William of St-Denis, *Epistola Encyclica*, ed. Lecoy, pp. 405–6. On William as Suger's secretary, see Glaser 1965:313.

6. There is no reason to believe that Hugh was the only advisor of importance to Suger; it is just that his imprint at St-Denis is the most readily identifiable.

7. No one in the world surpassed Hugh in knowledge of Scriptures according to an anonymous Victorine of the late twelfth century; Bonnard 1904:v.1:142–43. He had such a knowledge of divine things that no one in his time surpassed him, Richard of Poitiers wrote in his *Chronicon* ca. 1171; Hauréau 1886:vi. According to Bonaventure, Hugh was the greatest master and contemplative of the twelfth century; Zinn 1972:340. He is the only individual singled out beside the founder and first abbot in Robert of Torigny's account of the foundation of St-Victor, *De Immutatione Ordinis Monachorum* 5, PL 202:1313.

8. Smalley 1952:85. St-Victor maintained an open school in the early years of the house.

9. Bonnard 1904:v.1:13–14, 21–27.

10. Cf. the charters of 1126–1136 and of 1140, ed. Lecoy, pp. 370, 371; for an example of cooperation between Suger and Abbot Gilduin of St-

Victor of ca. 1127, see Bautier 1981:31. On Suger's cooperation with Abbot Gilduin in regard to Etienne de Garlande, Bonnard 1904:v.1:32. On Suger's considerable role in St-Victor's reform of Ste-Geneviève, see Bonnard 1904:v.1:160–65; Cartellieri 1898, register no. 196–98, 206–10.

11. Gabrielle M. Spiegel, "History as Enlightenment: Suger and the *Mos Anagogicus*," in Gerson 1986b:151. According to Bautier, Paris around this time had a population of approximately 2,500 laypeople with perhaps an additional 500 in the various religious establishments; Bautier 1981:39.

12. Hugh of St-Victor, *De Sacramentis* 2:1:4, PL 176:376; Peter of Celle (ca. 1115–1183) *Ep* 167, PL 202:610. On his originality, see Spicq 1944:120; Smalley 1952:99–100, 102; de Lubac 1959:pt.2:288. On breaking with iconographic tradition, see Zinn 1975:65–66. Yet Hugh was at the same time traditional: de Lubac 1959:pt.2:288–91.

13. The high degree of organization and clarity in Hugh's work speaks for itself: cf. the *Didascalicon* in general, and the discussion of the structure and significance of the ark and of the fifteen steps of the growth of wisdom in the hearts of the saints in particular; *De Arca Morali* 1:3–4, 2:18, and all of bk. 3, PL 176:626–34, 646, 646–64; cf. also the prologue of *De Meditatione*, p. 44. On Hugh's methodological application, see de Lubac 1959:pt.2:288, 296.

St-Denis does not necessarily employ theoretical geometry as opposed to practical geometry; cf. Bony 1986:135; Kimpel and Suckale 1985:89 find no evidence for an overall geometric system there. For Hugh's *Practica Geometriae*, see the recent critical edition by Roger Baron in *Hugonis de Sancto Victore Opera Propaedeutica* (Notre Dame, Ind., 1966), 15–64. References to geometry also occur in other works by Hugh. The title of Hugh's treatise on geometry, *Practica Geometriae*, is strikingly close to the expression *secundum geometriam practicans* used by Dominicus Gundissalinus in his *De Divisione Philosophiae* of ca. 1140–1150 to define the artist or craftsman; cited by von Simson 1974:33n.33.

14. Spicq 1944:120; de Lubac 1959:pt.2:288. The subject is too much of a constant in Hugh's writings to provide citations. On Hugh and allegory and exegesis in general, see Smalley 1952:87–106, esp. 99–100 on the originality of Hugh's exegesis; de Lubac 1959:pt.2:261–72. For Hugh as a renovator of exegesis and theology, see de Lubac 1959:pt.2:288; Baron 1957:97–124. Hugh saw allegory as served by geometry, *De Sacramentis*, chap. 6 of the prologue to bk. 1, PL 176:185.

15. *In Hierarchiam* was probably dedicated to Louis VII sometime between 1137 and early 1142. This is assuming that the dedication to Louis VII (crowned in 1137), which is absent from the earliest manuscripts and which describes Louis as a benefactor in the building of St-Victor, was

made by Hugh himself before the latter's death in March 1142 (the date of 1141 is apparently an error which is the result of changing calendrical systems). On the dating of *In Hierarchiam Coelestem*, see Van den Eynde 1960:58–65, 207; H. Weisweiler, *Dictionnaire de spiritualité*, 3:323–24. Weisweiler is supported by Bernard McGinn, "Pseudo-Dionysius and the Early Cistercians," *One Yet Two: Monastic Tradition East and West*, Cistercian Studies Series 29 (Kalamazoo, Mich., 1976), 212; and Jean Leclercq, "Influence and Noninfluence of Dionysius in the Western Middle Ages," *Pseudo-Dionysius: The Complete Works* (New York, 1987), 28. On the commentary in general, see René Roques, *Structures Théologiques: de la gnose à Richard de Saint-Victor* (Paris, 1962), 294–364. On the lateral portals, see Blum 1986. While these portals refer to Pseudo-Dionysius, they are not artistic projections of an anagogically functioning Pseudo-Dionysian mysticism, as will be explained later.

16. On St-Victor, see Bonnard 1904; J.-P. Willesme, "Saint-Victor au temps d'Abélard," *Abélard en son temps*, Actes du Colloque international organisé à l'occasion du 9ᵉ centenaire de la naissance de Pierre Abélard (Paris, 1981), 95–105. Louis confessed to Abbot Gilduin of St-Victor upon his death; Suger, *Vie de Louis VI* 34, pp. 282–84. St-Victor existed as a hermitage before William of Champeaux.

17. *Vita Prima* 1:31, PL 185:246.

18. *Vita Prima* 1:31, PL 185:246; Bonnard 1904:v.1:49–50. These transfers were not looked upon favorably by the Victorines, but good relations were eventually restored. On William's continued teaching at St-Victor, see Abelard, *Historia Calamitatum*, ed. J. Monfrin (Paris, 1959), 65.

19. St-Victor was allied with the bishop against his chapter; for an analysis of this situation, see Bautier 1981:65–77. It was to Bernard that Bishop Etienne de Senlis fled after the 1133 assassination of Thomas, the prior of St-Victor and the bishop's partner in the reform of the clergy; Bonnard 1904:v.1:32–37.

20. F. E. Croyden, "Abbot Laurence of Westminster and Hugh of St Victor," *Medieval and Renaissance Studies* 2 (1950): 169–71; Aelred Squire, "Aelred of Rievaulx and Hugh of St Victor," *Recherches de théologie ancienne et médiévale* 28 (1961) 161–64.

21. Hugh's treatise on baptism to Bernard is lost; cf. Van den Eynde 1960:132–37, 216. A treatise of 1127–1128 by Bernard to Hugh still survives; sometimes called *De Baptismo*, it is now published as *Ep 77*, v.7:184–200. On their mutual influence, see Baron, 178. On the confusion between their writings, see Hauréau 1886:165, 175–76, 180, 183, 213, 225. There was also a certain amount of dependence on William of Champeaux; Baron 1957:xl.

22. This study is not a formal discussion of either Hugh's or Bernard's artistic views, but only as they pertain to the program at St-Denis. I use the word "practice" here because I believe that Hugh and Bernard would largely have agreed in principle on the use of religious art but disagreed in actual interpretation of those principles; also, it is wrong to see the views of Hugh as identical with those of Suger.

23. These examples are too numerous to list. The Victorines did tolerate luxurious liturgical art in their early days, as is shown by the obituary of Hugh of St-Victor's uncle which records a gift of liturgical art as well as financial help and architectural direction in the building of the church; for the Latin text of this source see Jerome Taylor, *The Origin and Early Life of Hugh of St Victor: An Evaluation of the Tradition*, Texts and Studies in the History of Mediaeval Education 5 (Notre Dame, Ind., 1957), 60.

24. Hugh of St-Victor, *De Arca Morali* 1:2, 1:3, PL 176:622, 625, 629. It is clear from Hugh's *De Arca Mystica* that Hugh was competent at miniature painting. Hugh's entire text is a description, with some commentary, for those who wish to copy the drawing described by him in *De Arca Morali*. I say that Hugh must have been relatively accomplished on the basis of the complexity of the miniature. He may have received artistic training in school; see his somewhat idealistic description of the teaching of the extended liberal arts, including manuscript illumination, in Hugh of St-Victor, *De Vanitate* 1, PL 176:709. For a discussion of these works, see Zinn 1972 and Zinn 1975.

25. This is not meant as a comprehensive analysis either of the specific religious meaning of the sculptures or of their general social meaning— something I intend to take up in a later study. Most of the important parts of these sculptures have been recut or replaced, but their specific iconography remains certain thanks to the work of Crosby and Blum as it appears in their 1973 study.

26. Crosby and Blum 1973:219.

27. Although the cruciform halo is normally associated with the Son, it is not uncommon to find it in depictions of the Trinity as an attribute of the Father, numerous examples of which may be found in Adelheid Heimann, "L'iconographie de la Trinité," *L'art chrétien* 1 (1934) 37–55, and Adelheid Heimann, "Trinitas Creator Mundi," *Journal of the Warburg and Courtauld Institutes* 2 (1938) 42–52.

28. The summary of Gerson's work in this and the following paragraph comes from Gerson 1970:112–36, 162–67; Paula Lieber Gerson, "The Iconography of the Trinity at Saint-Denis," *Gesta* 17 (1978): 73; and Gerson 1986a. It does not pretend to be a complete presentation of her views.

29. Gerson 1986a:191. Emile Mâle, *L'art religieux du XIIe siècle en France*

(Paris, 1966), 400. Honorius Augustodunensis, *Elucidarium* 3:54 (3:23 in PL 172), ed. Y. Lefèvre (Paris, 1954), 458, 181 (for the sources of this passage). Augustine's discussion actually begins a little earlier in *De Trinitate* 1:12, but all the crucial elements are contained in *De Trinitate* 1:13.

30. A more complete study by Gerson of the Trinity at St-Denis is in progress.

31. Van den Eynde 1960:100–103, 207. As stated above, the *Testamentum* indicates that work on the west end was well underway by 1137.

32. Hauréau 1886:vi. For a short bibliography on the influence of Augustine in the works of Hugh, see Zinn 1975:62n.5.

33. The passage was abridged by Hugh. Hugh's writings are permeated with the thought of the Fathers, but the reason he depended so heavily on the direct quotation of Augustine concerning the Trinity in particular seems to be the difficulty and importance of the subject: as Augustine said, no other subject of theology is more "dangerous"; *De Trinitate* 1:3:5, p. 32.

34. Unless otherwise noted, all references to Augustine are from *De Trinitate* 1:13, pp. 69–79.

35. This is the case with *De Trinitate* 1:13, and is especially so in Augustine's summary of the book in *De Trinitate* 15:3:5, pp. 463–67.

36. Hugh of St-Victor, *De Sacramentis* 1:8:5, PL 176:310; cf. *De Sacramentis* 2:18:16, PL 176:613–14.

37. This does not preclude other levels of meaning here in respect to the cross. It is interesting that while Hugh chose to omit much of *De Trinitate* 1:13, he interpolated one sentence from *De Trinitate* 15:25:49, p. 531, and that sentence refers to Christ and the cross; Hugh, *De Sacramentis* 2:17:7, PL 176:599: "For Christ is not to be seen again on the Cross (*non enim Christus iterum in cruce videndus est*)." At St-Denis, Christ does not appear on the cross (*in cruce*), but in front of the cross.

38. The bosom of Abraham (Luke 16:22) is identified with both limbo and with heaven itself. Its use at St-Denis may be understood as referring to heaven because of its association with the palace of heaven and the angel holding souls.

It seems to be significant that unlike Conques and Autun, these souls are in the archivolts—that is, removed from the center of action of the tympanum or lintel, a center of action which is the place of judgment. On the iconographical relation of the twenty-four elders to the last judgment, see Peter Klein, "Eschatologie présent et future dans les portails du XIIe siècle: Moissac, Beaulieu et Saint-Denis," which I have read in typescript, and which is to appear in the acts of the Santiago symposium of 1988.

39. Hugh of St-Victor, *De Sacramentis* 2:17:8, PL 176:600; Augustine,

Epistulae, ed. A. Goldbacher, Corpus Scriptorum Ecclesiasticorum Latinorum 57 (Vienna, 1911), 335–36; Gregory the Great, *Moralia in Job* 26:27:50, ed. M. Adriaen, Corpus Christianorum: Series Latina 143 (Turnhout, 1979–1985), 1304–05.

40. Hugh of St-Victor, *Didascalicon* 4:2, 5:7, p. 72, 105. On the influence of Gregory the Great on Hugh, see Baron 1957:169–70.

41. My thanks to John Williams for pointing out that this passage from the *Moralia in Job* is also the same source for the Beatus illustration of the last judgment; cf. John Williams, *Early Spanish Manuscript Illumination* (New York, 1977), pl. 21–22.

42. Ehlers 1973:63. The Augustinian basis was expressed at St-Victor in a sermon on the completion and joy of the Church Militant and Triumphant which Richard of St-Victor wrote for the feast of St Augustine using Hugh's formulation of the theory of creation and restoration. Jerusalem or the Church is spoken of as having one portal with two doors: two yet one. One is the Creator and the other is the Savior; Richard of St-Victor, ser.84, PL 177:1167–68. This is particularly interesting in light of Gerson's observation that the west central portal of St-Denis probably represents the first portal program in the West to emphasize the theme of Christ as the door; Gerson 1986a:186n.15.

43. Hugh of St-Victor, *De Sacramentis*, chap. 2 of the prologue to bk. 1, PL 176:183.

44. Hugh of St-Victor, *De Sacramentis*, chap. 2 of the prologue to bk. 1, 1:10:2, 1:10:5, 1:10:8, PL 176:183–84, 329, 334, 341. Hugh does not mean that the divine nature of Christ suffered along with the human nature, only that the union between the divine and the human was perfect.

45. Hugh of St-Victor, *De Sacramentis*, chap. 3 of the prologue to bk. 1, PL 176:184.

46. Hugh of St-Victor, *De Sacramentis* 1:8:11, 1:8:12; on Hugh's definition of the sacraments in general, see *De Sacramentis* 1:9:2, PL 176:317–19.

47. Acts of Pilate, version Latin A 19, 23, 24, ed. M. R. James, *Apocryphal New Testament* (Oxford, 1924), 127–28, 137–39, discusses this with regard to Adam. Although Eve's absence in Latin A is not a theologicial difficulty and is implied in the presence of "all his saints," Acts of Pilate, version Latin B 25, ed. M.R. James, pp. 137–38, does mention Eve as well.

48. *Vita Adae et Evae* 42 (interpolated from the Acts of Pilate), 48, ed. H.F.D. Sparks, *The Apocryphal Old Testament* (Oxford, 1984), 158, 160.

49. Irenaeus, *Adversus Omnes Haereses* 3:23:2, 3:23:7, 3:23:8, in *Contre les hérésies: Livre III* ed. A. Rousseau (Paris, 1974), v.2:448–50, 464, 466–68.

50. Etienne Gilson, *The Mystical Theology of St Bernard* (New York, 1940), 38.

51. Hugh of St-Victor, *De Sacramentis* 1:7:10, PL 176:291; 1 Cor. 15:45–49. Cf. Rom. 5:12–21; 1 Cor. 15:22; Luke 3:38.

52. In *In Pentateuchon* 7, PL 175:37–39, Hugh discusses the creation of man strictly in terms of mankind, and not of Adam as an individual. In this he follows the venerable tradition of Origen, as in *Contra Celsum*, 4:40, in *Contre Celse*, ed. M. Borret (Paris, 1967–1976), v.2:288.

53. It should be noted that Christ is often depicted as the Creator (creative power) in creation scenes. Again, Hugh does not mean that the divine nature of Christ suffered along with the human nature, only that the union between the divine and the human was perfect.

54. Augustine, *De Trinitate* 1:13:31, p. 77.

55. Hugh of St-Victor, *De Sacramentis* 1:8:5, PL 176:310.

56. Hugh of St-Victor, *De Sacramentis* 1:3:24, 1:3:27, 2:1:4, PL 176:226, 229, 379. Augustine is held to have been one of the major supporters of this dogma; cf. *De Trinitate* 4:20:29, 4:21:32, 5:14:15, 15:26:47–15:27:48, pp. 199, 205, 223, 527–30.

57. That is, the Father is not completely concealed, but rather there is enough of him showing to indicate that it is indeed the Father that is behind the disk—as required by the nature of visual expression.

58. Hugh of St-Victor, *De Sacramentis* 2:17:7, PL 176:599; the biblical quotation is from John 19:37. Cf. Apoc. 1:7; Augustine, *De Trinitate* 1:13:29, p. 73; and Augustine, *De Beata Vita* 4:35, p. 84.

59. Hugh of St-Victor, *In Hierarchiam* 2, PL 175:939–40.

60. Hugh of St-Victor, *De Sacramentis* 2:8:5, 2:6:8, 2:8:1, PL 176:465, 454, 461.

61. Hugh of St-Victor, *In Hierarchiam* 1:1, PL 175:926–27.

62. Hugh of St-Victor, *De Sacramentis* 2:6:8, PL 176:455. The passion is represented in the bronze doors of the portal, in the instruments of the passion in the tympanum, in the cross so unusually and so centrally aligned with Christ, and in the Lamb. I recognize that the instruments of the passion also carry other connotations than suggested here.

63. Cf. Hugh of St-Victor, *In Hierarchiam* 2, PL 175:946, 948. For the relation between the meaning of the sculptures and Suger's inscription on the bronze door, see below. This analysis does not preclude other levels of meaning, the reason for which will also be taken up later.

64. Hugh of St-Victor, *De Arca Mystica* 1, 4, 15, PL 176:681–82, 687, 701–2. I am currently working on a translation of *De Arca Mystica* and its relation to the art program at St-Denis.

65. Baron 1957:168–73.

66. This and the references to Gerson in the previous paragraph are from Gerson 1986a:186, 193–94.

CHAPTER 6

1. Chenu 1957:125. All discussion in this and the following two paragraphs is based on Chenu 1957:80–83, 119–28 and comments made by Stephen Gersh after his generous reading of this manuscript unless otherwise indicated or implied. The terms "symbol" and "sign" are used by Chenu for clarity: Pseudo-Dionysius and Augustine do not strictly follow this usage, nor does Hugh. On Pseudo-Dionysius, see René Roques, *L'univers Dionysien: structure hiérarchique du monde selon pseudo-Denys* (Paris, 1954); and Rorem 1984. Even one as well-versed in theology as Meister Eckhart confused Augustine with Pseudo-Dionysius; Rorem 1984:144.

2. Pseudo-Dionysian anagogy, or spiritual ascent, is not the same anagogy of the exegetical interpretation of Scripture, which is a revelation of that for which one ought to strive. For a more detailed analysis than Chenu's of Pseudo-Dionysius's anagogy, see Rorem 1984:99–105.

3. For example, Pseudo-Dionysius, *De Ecclesiastica Hierarchia* 3:3:1, 7:3:11, PL 122:1081, 1110; *De Caelesti Hierarchia* 1:3, 2:3, PL 122:1039, 1041–42. I use Erigena's translation of Pseudo-Dionysius since this was the one available to Hugh of St-Victor and Suger.

4. Pseudo-Dionysius, *De Caelesti Hierarchia* 2:5, PL 122:1043.

5. *Pretiosioribus sacris formationibus*, Pseudo-Dionysius, *De Caelesti Hierarchia* 2:3, PL 122:1041–42.

6. Pseudo-Dionysius, *De Caelesti Hierarchia* 2:4, PL 122:1043; *De Divinis Nominibus* 4:11, PL 122:1135.

7. Chenu also sees the *De Sacramentis* as dominated by the Augustinian sign as opposed to the Pseudo-Dionysian symbol; Chenu 1957:127.

8. 1 John 1:5, cited by Augustine, *De Trinitate* 8:2:3, p. 271; James 1:17; 1 Tim. 6:16; Rom. 1:20; Wis. 13:5; Augustine, *De Trinitate* 15:2:3, p. 462; Augustine, *De Doctrina Christiana*, 1:4, 1:10, pp. 8, 12. Cf. 2 Cor. 4:18, Col. 1:15–20. On light, the early Christian tradition, and St-Denis, see Kidson 1987:6–7.

9. His one overt reference to light and art is thoroughly non-Pseudo-Dionysian; Suger, *De Cons* 4, p. 100; cf. *De Cons* 5, p. 106.

10. *De Cons* 1, 7, pp. 82–84, 120; commented on by Panofsky 1979:26; as noted by von Simson 1974:125.

11. For a possible stimulus to Suger's unconvincing denial of the appeal of art to the senses, see the more realistic subordination of art and the senses to the spiritual by Hugh of St-Victor, *De Arca Morali* 1:2, PL 176:622, quoted later.

12. Suger, *De Adm* 27, pp. 46–48; cf. the punctuation in ed. Lecoy, p. 189. My translation of this inscription differs from Panofsky's.

13. Cf. 1 John 2:8; Pseudo-Dionysius, *De Caelesti Hierarchia* 1:2, PL 122:1037; Hugh of St-Victor, *In Hierarchiam* 1:5 (cf. John 1:9), 2, PL 175:933, 955.

14. Perhaps it is to this inscription that the epitaph of Suger by Simon Chièvre d'Or, a canon regular of St-Victor, referred when he wrote: "*Cui rapuit lucem lux septima Theophaniae,/ Veram vera Deo Theophania dedit*"; ed. Lecoy, p. 422.

15. It is improbable that a direct written source for this inscription exists. Certainly, if one wishes parallels, one may easily find a number of them quite closer than those of Erigena cited by Panofsky 1979:24. Cf. Hugh of St-Victor, *Didascalicon* 7:15, PL 176:824–25 (bk. 7 is separate from the rest of the *Didascalicon*, and so is not in Buttimer's ed.); *In Hierarchiam* 1:5, 2, PL 175:932–33, 955; cf. *De Sacramentis* 1:1:12, PL 176:196.

16. Suger himself, rather than Hugh, seems to be the one responsible for this particular use of Pseudo-Dionysian thought as a defense of materialism.

17. Although I have not studied in depth any of the other references to Dionysius of which the west end is full (cf. Blum 1986:199–227), a cursory examination suggests that they do not affect this thesis.

18. While the letter of Gregory to Secundinus is spurious, it was cited as if authentic by the Council of Paris in 825 in defense of religious art; Gregory the Great, *Ep*, app. 10, pp. 1110–11 (*Ep* 9:52 in PL 77:990–91); *Concilium Parisiense A. 825* 14, MGH, Leg 3, Concilia, v.2:pt.2:489. The spurious letter of Gregory likens this meditative function of art to the reading of Scripture.

19. As to Suger's east end inscription (*De Adm* 28, p. 50), Panofsky agreed with Meyer Schapiro's suggestion that this particular inscription was probably based on certain Neoplatonic inscriptions which Suger would have seen in his travels in Italy; Panofsky 1979:22, 164–65, 168–69. Beyond this, however, Panofsky's argument that it is an "orgy of neo-Platonic light metaphysics" is, in my opinion, unconvincing. Rather, given the possibility of influence from the Italian neoplatonic inscriptions, the east end inscription seems to be little more than a reference to the brightness of the choir that Suger prized so highly, joined to the brightness of the novel rose of the west end. Cf. *De Cons* 4, p. 100 on the light of the east end; *De Adm* 34, p. 72 on the rose; and William of St-Denis, *Vita Sugerii* 2:9, ed. Lecoy, p. 391 who noted Suger's desire to make a "shining" church. Hugh had also been to Italy; see F. E. Croyden, "Notes on the Life of Hugh of St Victor," *Journal of Theological Studies* 40 (1939): 250–53. For Kidson's views that Suger had little or no understanding of the role of Neoplatonism in Christianity and that the early Christian Neo-

platonists were in any case not concerned with art, see Kidson 1987, esp. 5–7.

20. Suger, *De Adm* 33, pp. 62–64; my translation differs from Panofsky's.

21. Pseudo-Dionysius, *De Caelesti Hierarchia* 15:7, PL 122:1068. Apparently neither Erigena nor Hugh felt that the passage was an important one, including its reference to the properties of precious stones. Erigena made no comment on it, and Hugh only clarified its confusing language, noting that "anagogical" meant "spiritual"; Hugh of St-Victor, *In Hierarchiam* 10, PL 175:1149. This is not to deny Suger's obvious special attraction to luxurious materials.

22. Panofsky 1979:191.

23. Hugh of St-Victor, *De Arca Morali* 3:7, PL 176:654. Hugh is not one of the Fathers, and so there is no reason to expect verbal dependence. Hugh uses the same words in this passage that he uses elsewhere to define anagogy: "Anagogy is an ascent or elevation of the mind to contemplate supernal things" (*elevatus/elevatio, ascendit/ascensio*); *In Hierarchiam* 1, PL 175:941. For other passages in Hugh's writings which may have stimulated Suger, see *De Arca Morali* 4:2, PL 176:666; *De Vanitate Mundi* 2, PL 176:713. Kidson sees Suger's passage on precious stones as autobiographical; Kidson 1987:7.

24. Hugh of St-Victor, *In Hierarchiam* 1:1, PL 175:923–25. Augustine also began his *De Trinitate* with such an attack, 1:1, pp. 27–28. For a somewhat different criticism of secular learning by Hugh, see *De Arca Morali* 4:8, PL 176:674.

25. Hugh of St-Victor, *In Hierarchiam* 1:2, PL 175:927.

26. *Summa ratio*; *De Cons* 1, p. 82.

27. Perhaps von Simson's comment on Bernard's role in the Augustinian influence on Gothic art should be revised to include Hugh of St-Victor, who wrote extensively on beauty; von Simson 1974:56.

28. Suger, *De Adm* 34, pp. 72–74.

29. For the most complete study of these windows, see Louis Grodecki, *Les vitraux de Saint-Denis: Etude sur le vitrail au XIIe siècle*, Corpus Vitrearum Medii Aevi, France, Etudes 1 (Paris, 1976), v.1.

30. Suger, *De Adm* 34, p. 74; cf. Panofsky 1979:20; my translation differs slightly from Panofsky's. As mentioned earlier, Suger's reference to the windows in *De Cons* 4, p. 100 is not Pseudo-Dionysian.

31. Louis Grodecki, "Abélard et Suger," *Pierre Abélard, Pierre le Vénérable* (Paris, 1975), 283–84; Grodecki 1961:22–24, 27, 32–35, 41. Grodecki's thesis is undeveloped, as is that of Kimpel and Suckale who, while accepting the use of Pseudo-Dionysius by Suger as a justification of his mys-

tical light theory, see no causal relation between Pseudo-Dionysian theology and the architecture of St-Denis; Kimpel and Suckale 1985:90.

32. Suger, *De Adm* 34, p. 74; my translation differs from Panofsky's.

33. Augustine, *In Joannis* 24:5, p. 246: "*quinque panes intelleguntur quinque libri Moysi; merito non triticei, sed hordeacei, quia ad Vetus Testamentum pertinent. Nostis autem hordeum ita creatum, ut ad medullam eius vix perveniatur; vestitur enim eadem medulla tegmine paleae, et ipsa palea tenax et inhaerens, ut cum labore exuatur. Talis est littera Veteris Testamenti, vestita tegminibus carnalium sacramentorum; sed si ad eius medullam perveniatur, pascit et satiat.*" Cf. Augustine, *In Joannis* 24:1, 25:13 (where reference is made to the "true bread"), pp. 244, 255.

34. Augustine, *De Doctrina Christiana* 3:18, pp. 88–89: "*tota figurata sunt, quorum ad caritatis pastum enucleanda secreta sunt.*" *Enucleare* literally means to take a kernel from its husk, although wheat is not specifically demanded. It seems that the explicit reference to wheat in Suger's inscription, aside from its eucharistic connotations, is based on Matt. 13:10–43, where grain and bread imagery is used in one of the most important scriptural passages on the subject of allegory; on the importance of this passage, Wailes 1985:43–44, 50–51. Kidson 1987:10 sees the iconography of the windows as Suger's own contribution.

35. For Augustine's theory of signs, *De Doctrina Christiana* 1:2–1:4, 1:13, 2:1–2:3, 2:15, pp. 7–8, 13–14, 32–33, 41. This is not a complete presentation of Augustine's views.

36. Augustine, *De Doctrina Christiana* 3:14, 3:18, 3:25, 4:23, pp. 86, 88–89, 92–93, 132.

37. Augustine's system of a gradation of knowledge has a long tradition and is related to the theory of the function of parables in the Middle Ages; on this see Wailes 1985, who makes ample reference to the primary sources and secondary literature. There is also a system of a gradation of knowledge in Pseudo-Dionysian mysticism.

38. Augustine, *De Doctrina Christiana* 2:7, 4:9, 4:22, 2:8, 4:15, pp. 35, 122, 131, 36, 127. Although Augustine's approval of the use of signs as spiritual aids is associated with such things as baptism and the Eucharist, it does not explicitly rule out Christian art; Augustine, *De Doctrina Christiana* 3:13, pp. 85–86; but cf. 3:11, pp. 84–85.

39. Chenu 1957:119. On Hugh's approach to exegesis, *Didascalicon* 5:2, pp. 95–96; *De Sacramentis*, chap. 4 of the prologue to bk. 1, PL 176:184–85.

40. Hugh of St-Victor, *Didascalicon* 6:4, p. 122; *De Sacramentis*, chap. 6 of the prologue to bk. 1, PL 176:185; *De Arca Morali* 1:2, PL 176:625; *Didascalicon*, pref. (1:1 in PL ed.), p. 2; *De Arca Morali* 2:8, 3:15, PL 176:642, 662; *De Vanitate* 1, PL 176:704. Hugh's enthusiastic recommendation of the

Epistles of Paul is probably based on Augustine, *Confessiones* 7:21:27, p. 110.

41. Hugh of St-Victor, *De Arca Morali* 4:4, PL 176:670; cf. Augustine, *De Doctrina Christiana* 2:8, 4:22, pp. 36, 131.

42. On Augustine, see, for example: *Confessiones* 10:33:50–52, 10:34:53, pp. 181–84; *De Doctrina Christiana* 2:39, 3:11, 3:13, pp. 61, 84–85, 85–86; *Soliloquiorum* 2:10:18, PL 32:893.

43. Hugh of St-Victor, *De Arca Morali* 1:2, PL 176:622. Hugh's views on art and spirituality are too complex to be dealt with fully here. It should be noted, however, that the qualification regarding the senses has similarities with Suger's later denial of the senses in relation to his denial of materialism in *De Consecratione*; see above. *Virtus* might be described as the fortitude and excellence of character that both lead to moral superiority and are the result of it.

44. Leclercq 1974:18–22.

45. "*Et quoniam tacita visus cognitione materiei diversitas, auri, gemmarum, unionum, absque descriptione facile non cognoscitur, opus quod solis patet litteratis, quod allegoriarum jocundarum jubare resplendet, apicibus litterarum mandari fecimus. Versus etiam idipsum loquentes, ut enucleatius intelligantur, apposuimus,*" Suger, *De Adm* 33, p. 62; my translation differs from Panofsky's. As Panofsky noted, parts of Suger's writings are confusing and almost untranslatable. The question here is whether *materies* which is not easily understood means "subject matter" or "materials." Since Suger clearly indicated that it is the allegories that are being explained by the inscriptions, it logically follows that it would also be the allegories that are the *materies* which needs explanation; and perhaps this is why he used the word *materies* rather than *materia* which had just been used previously in the same chapter to indicate "material," while the adjectival form of *materia*, *materialis*, was employed almost immediately after.

There was no "guide" to the iconography or labels explaining the magical properties of precious stones as Panofsky 1979:188–89 suggests. The "description" Suger talks about in the one sentence follows quite logically in the next: it is simply the "explanatory verses." The artworks apparently looked like the antependium of Charles the Bald (fig. 6), where gems and pearls actually formed part of the golden imagery itself. The poem, *De Nobilitate Domini Sugerii Abbatis et Operibus Eius* (ed. Lecoy, p. 424) also speaks of the three panels installed by Suger, and so the relief panel, as replete with jewels. Possibly Suger was concerned with the "concordance and harmony" of the antependium and his new additions to it in the same way that he was with the dimensions and columns of the old and new church.

46. It is in this sense that I use the term *litterati* (as compared with the contemporary meaning of "literati"). On the use of the term *litteratus* as meaning choir monk, see *Constitutiones Hirsaugienses* 2:11, in *Vetus Disciplina Monastica* ed. M. Hergott (Paris, 1726), 484–85; Giles Constable, " 'Famuli' and 'Conversi' at Cluny: A Note on Statute 24 of Peter the Venerable," *Revue Bénédictine* 83 (1973) 334–35. Although of interest, this is not the place to take up the question of *litteratus* as applying to those other than monks. John of Salisbury, Suger's contemporary, did not even consider a literate person to be a *litteratus* unless he was widely read; *Policraticus* 7:9, in *Ioannis Saresberiensis Episcopi Carnotensis Policratici . . .* , ed. C.C.J. Webb (Oxford, 1909), v.2:128; John, however, was not referring specifically to spiritual reading. The traditional Benedictine *conversi*, sometimes called lay brothers, were not as strictly segregated from the choir monks as were the Cistercian *conversi* who eventually came to be made up almost solely of the peasant class.

47. The spurious letter of Gregory the Great mentioned earlier likens certain meditative functions of art to scriptural reading (the literacy of the worshiper being implied), although not in the sophisticated way of Suger and Hugh, and so not actually able to be used as a direct justification by Suger; Gregory the Great, *Ep*, app. 10, p. 1111 (*Ep* 9:52 in PL 77:991).

48. My thanks to Joseph Wawrykow for pointing out that both Augustine and Hugh are in the sapiential tradition—a tradition of scriptural study which saw in the things of creation the potential means to a better understanding of God—something quite distinct from the anagogy of Pseudo-Dionysius. The idea of church windows as symbolizing the Church Fathers with light symbolism being used in a non-mystical way is very strong in Richard of St-Victor, *Sermones Centum* 1, 2, PL 177:902–03, 904, 905. Cf. *Miscellanea* 7:2, PL 177:869, which is along similar lines.

49. In his discussion of monasticism, art, and the layman, Bernard of Clairvaux noted that the monk had left "the people" behind; *Apologia* 28, v.3:105.

The art of St-Denis is "obscure," not "obscured." That is, while such overt levels of meaning as the judgment per se and the Trinity per se would have been recognized by all, the way in which they were used and the sophistication of their more complex levels of meaning were based on a highly specialized body of knowledge and literature. It is not the same concept as the "disguised symbolism" of Panofsky and as discussed, for example, in James Marrow, "Symbol and Meaning in Northern European Art of the Late Middle Ages and the Early Renaissance," *Simiolus* 16 (1986): 150–69; and Larry Silver, "The State of Research in Northern European Art of the Renaissance Era," *Art Bulletin* 68 (1986): 518–35.

50. Suger, *De Cons* 4, 5, pp. 100, 104; he also expresses a general concern for the "uninterrupted" view of the ambulatory windows, although whether for monk or for visitor is not stated. Suger does mention concern with the general interior vista in *De Adm* 34, p. 72.

51. Bernard makes the same distinction between "spiritual men" and "carnal men" in relation to art, but in a negative way; Bernard of Clairvaux, *Apologia* 28, v.3:104–6; as does William of St-Thierry, *Epistola ad Fratres de Monte Dei* 156, in *Lettre aux frères du Mont-Dieu*, ed. J. Déchanet (Paris, 1975), 266. The reference to "spiritual men" is from Gal. 6:1. Cf. Hugh below.

52. *Monachus autem non doctoris habet, sed plangentis officium*; Jerome, *Contra Vigilantium* 15, PL 23:351 (or 367 in the 1845 ed.). Cf. *officium [monachi] non est docere, sed lugere*, Bernard of Clairvaux, *Ep* 89:2, v.7:236.

CHAPTER 7

1. Hugh, *Didascalicon* 7:4, PL 176:814 (bk. 7 is separate from the rest of the *Didascalicon*, and so is not in Buttimer's ed.); this passage is based on Augustine, *In Ioannis* 24:2, pp. 244–45.

2. Nor was it an accident that Suger himself had neatly distributed part of the cost of the art program between those abbey revenues which were specifically from lay sources and those which were specifically from the monastic domain; Suger, *De Cons* 4, p. 103 (taken from the *Ordinatio*). One hundred pounds were to be taken annually from the offerings made at the Lendit, fifty from those made at the Feast of St Dionysius, and fifty from the abbey's properties at Villaine (with a back-up in case Villaine should fail).

3. Suger's major discussion of the structural aspects of the architecture of the east end makes no reference to the new style; Suger, *De Cons* 5, p. 108.

4. Suger, *De Adm* 34, pp. 72–74. Suger was by no means solely concerned with figural art. On the contrary, his personal predilection seems to have been in the direction of the so-called minor arts, something which coincided well with his affinity for the liturgy as noted repeatedly by William of St-Denis, *Vita Sugerii* 1:4, 2:7, ed. Lecoy, pp. 381, 390; *Epistola Encyclica*, ed. Lecoy, p. 405. However, it is the role of figural art with which this study is concerned.

5. Suger, *De Cons* 4, p. 100; quoted below; the sense of this passage is that the "interior beauty" of the church is traversed by sunlight, allowing it to shine; it is not overtly based upon Pseudo-Dionysian light mysticism. William of St-Denis, *Vita Sugerii* 2:9, ed. Lecoy, p. 391.

6. In this particular study of the relation of the glass to the viewer, I consider the window to be only the distance from the bottom of the glass to the top of the glass; I consider the wall surface to be the distance from the floor to the top of the glass. These figures, while worked out to the percentage point, are approximates only; they are made from published architectural elevations, not from specific measurements.

7. Bony 1986:134–35.

8. Bony 1983:106.

9. Suger's approach to effect eventually took hold, the windows of Amiens comprising around seventy-five percent of the total wall surface, but with a considerably greater absolute distance to the viewer.

10. "But since this kind of painting [mural painting, mentioned in the previous book] cannot be translucent, I have, like a diligent seeker, taken particular pains to discover by what ingenious techniques a building may be embellished with a variety of colors, without excluding the light of day and the rays of the sun"; Theophilus, *De Diversis Artibus*, pref. to bk. 2, *The Various Arts*, ed. and trans. C. R. Dodwell (London, 1961), 37; i.e., since the one kind of painting prohibits light, he will discuss the kind that doesn't—the art forms which differ physically are equated conceptually. Cf. also William Durandus of Mende, *Rationale Divinorum Officiorum* 1:3:5, (Naples, 1859), 24, for what is probably a similar equation, although somewhat less direct: *"aliae* [images] *intra* [the church], *ut conae statuae et diversa sculpturarum et picturarum genera, quae vel in parietibus, vel in vitrealibus depingitur."*

11. Athough his exact meaning is ambiguous, one of Suger's references to the chevet and its windows is of special interest in this regard. The passage is not an easy one, with a very literal translation reading: "with the exception of that elegant and proven [or approved?] addition in the circling around of chapels, by which [i.e., by which addition]—traversing the interior beauty [of the church] with the wonderful and uninterrupted light of the most brilliant windows—the whole may shine (*excepto illo urbano et approbato in circuitu oratoriorum incremento, quo tota clarissimarum vitrearum luce mirabili et continua interiorem perlustrante pulchritudinem eniteret)*," Suger, *De Cons* 4, p. 100. Although it may be that Suger is simply referring to the new ambulatory design as "proven" in its efficiency of design, or even "approved" by precedent for ecclesiastical architecture, the possibility also exists that he is speaking of the design of the ambulatory and its windows as "approved" in the sense of Bernard of Angers' reference to the general tradition which approved of only certain forms of art for the depiction of certain subjects, the mural being one of these. Suger uses the word *approbo* in both senses of "approved" and "proven"

almost equally; Suger, *De Adm* 33, p. 66; *Ord*, pp. 130, 132; *Vie de Louis VI*
10, 14, 16, 18, 27, pp. 60, 86, 106, 126, 216. While I do not insist on this
interpretation, the brilliance of the windows is the main subject of this
crucial passage on the ambulatory and—perhaps significantly—in the sen-
tence immediately following the one in question Suger characterizes his
program for the east end, saying, "with wise counsel and under the dic-
tation of the Holy Spirit, whose unction instructs us in all things, that
which we proposed to carry out had been designed with bright (*luculento*)
order," thus referring to both the correctness of the program and to its
windows. *Luculento* carries a range of meanings from "full of light" to
"distinguished"; both of the translations in this note differ somewhat
from Panofsky's.

12. According to Gardner, the second master "went to considerable
trouble" to increase window size in relation to the work of the first master;
this was so much the case that the second master may even have taken
down some of the work of the first master to increase window size; Gard-
ner 1984:580n.24, 585.

13. *Versus in Laudem Sugerii Abbatis*, ed. Lecoy, p. 425; attributed to Wil-
liam of St-Denis by Glaser 1965:261–68.

14. See Gardner 1984 in general; this is also the opinion of Kidson
1987:10–11, 14, 17.

15. Rudolph 1987:21–28. Also, it was probably the Cistercian Adam of
Dore who wrote the *Pictor in Carmine*, a collection of types and antitypes,
for the stated purpose of providing suitable material for both the unedu-
cated and the "*litterati*"—a goal much more in keeping with Suger's con-
ception of art than with Bernard's; *Pictor in Carmine*, p. 142.

CHAPTER 8

1. Hugh was not necessarily the only advisor of importance to Suger.

2. I wish to emphasize that I am only concerned with Suger's claims
and their contradictions in this study. Much of the art not mentioned by
Suger in his explicitly justificative writings was quite capable of being un-
derstood on a popular, religious level although it is not specifically secu-
lar. In contrast, this function of religious art becomes of great importance
in the art of the cathedrals; see the discussion of the *stilus humilis* in Wolf-
gang Kemp, *Sermo Corporeus: Die Erzählung der mittelalterlichen Glasfenster*
(Munich, 1987), 132–60. Cf. also the statement from the preface of the
Pictor in Carmine which describes "paintings of that kind which bring di-
vine things to mind to the simple, and which excite the *litterati* (*literatos*)

to the love of Scripture . . . [further noting that this type of art had been] already begun in many churches"; *Pictor in Carmine*, pp. 142–43.

3. Cf. Henri Focillion's view that in the *Apologia* Bernard perceived the incipient decline of the Romanesque style, overcome by "Baroque vegetation," and proclaimed the exhaustion of the Romanesque, calling for a more austere architecture which would at the same time provide a more pleasing economy of design; *Art d'Occident, le moyen âge roman et gothique*, 3d ed. (Paris, 1955), 157, 220.

4. On the monk and the nonmonk as basic social divisions, see George Duby, *The Three Orders: Feudal Society Imagined* (Chicago, 1980), 177–78.

5. According to Félibien 1706:172, Bernard's *Ep* 225, v.8:94, probably refers to the ceremony of the consecration of the east end of St-Denis; Vacandard 1902:v.2:204, supports such an interpretation. This would mean that Bernard attended the consecration as one of the abbots mentioned in Suger's account, the same ceremony for which the mutton was "miraculously" provided; *De Cons* 5, 6, pp. 108–10, 114.

BIBLIOGRAPHY

PRIMARY SOURCES

Augustine, *De Beata Vita*: Augustine, *De Beata Vita*, ed. William M. Green, Corpus Christianorum: Series Latina 29 (Turnhout, 1970), 63–85.

Augustine, *Confessiones*: Augustine, *Confessionum Libri XIII*, ed. Lucas Verheijen, Corpus Christianorum: Series Latina 27 (Turnhout, 1981).

Augustine, *De Doctrina Christiana*: Augustine, *De Doctrina Christiana*, ed. J. Martin, Corpus Christianorum: Series Latina 32 (Turnhout, 1962).

Augustine, *De Trinitate*: Augustine, *De Trinitate*, ed. W. J. Mountain, Corpus Christianorum: Series Latina 50 (Turnhout, 1968).

Augustine, *In Joannis*: Augustine, *In Joannis Evangelium Tractatus CXXIV*, ed. R. Willems, Corpus Christianorum: Series Latina 36 (Turnhout, 1954).

Bernard of Angers, *Liber Miraculorum*: Bernard of Angers, *Liber Miraculorum Sancte Fidis*, ed. A. Bouillet, Collection de textes pour servir à l'étude et à l'enseignement de l'histoire 21 (Paris, 1897).

Bernard of Clairvaux, *Sancti Bernardi Opera*, ed. Jean Leclercq and Henri Rochais (Rome, 1957–1977).

Gregory the Great, *Ep*: Gregory the Great, *Registrum Epistularum Libri*, ed. Dag Norberg, Corpus Christianorum: Series Latina 140 (Turnhout, 1982).

Hugh of St-Victor, *De Arca Morali*: Hugh of St-Victor, *De Arca Noe Morali*, PL 176:617–80.

Hugh of St-Victor, *De Arca Mystica*: Hugh of St-Victor, *De Arca Noe Mystica*, PL 176:681–704.

Hugh of St-Victor, *De Meditatione*: Hugh of St-Victor, *De Meditatione*, ed. Roger Baron, *Hugues de Saint-Victor: Six opuscules spirituels*, Sources chrétiennes 155 (Paris, 1969), 44–58.

Hugh of St-Victor, *De Sacramentis*: Hugh of St-Victor, *De Sacramentis*, PL 176:183–618.

Hugh of St-Victor, *De Vanitate*: Hugh of St-Victor, *De Vanitate Mundi*, PL 176:703–40.

Hugh of St-Victor, *Didascalicon*: Hugh of St-Victor, *Didascalicon*, ed. Charles Buttimer, Catholic University of America: Studies in Medieval and Renaissance Latin 10 (Washington, 1939).

Hugh of St-Victor, *In Hierarchiam*: Hugh of St-Victor, *In Hierarchiam Coelestem*, PL 175:923–1154.

John of Salisbury, *Historia*: John of Salisbury, *Historia Pontificalis*, ed. and trans. Marjorie Chibnall (London, 1956).

Matthew of Albano, *Ep*: Matthew of Albano, *Epistola Matthaei Albanensis Episcopi*, ed. S. Ceglar, "Guillaume de Saint-Thierry et son rôle directeur aux premiers chapitres des abbés Bénédictins: Reims 1131 and Soissons 1132," *Saint-Thierry: une abbaye du VIe au XXe siècle*, Actes du Colloque international d'Histoire monastique (Saint-Thierry, 1979), 320–33.

Odo of Deuil, *De Profectione*: Odo of Deuil, *De Profectione Ludovici VII in Orientem*, ed. and trans. V. G. Berry, Records of Civilization: Sources and Studies 42 (New York, 1948).

Orderic Vitalis, *Ecclesiastical History*: Orderic Vitalis, *The Ecclesiastical History of Orderic Vitalis*, ed. and trans. Marjorie Chibnall (Oxford, 1969–1978).

PG: *Patrologia Graeco-Latina*, ed. J. P. Migne, 162 v. (Paris, 1857–1866).

Pictor in Carmine: *Pictor in Carmine*, ed. M. R. James, "Pictor in Carmine," *Archaeologia* 94 (1951): 142–43.

PL: *Patrologia Latina*, ed. J. P. Migne, 221 v. (Paris, 1844–1864).

Pseudo-Dionysius, *De Caelesti Hierarchia*: Dionysius, the Pseudo-Areopagite, *De Caelesti Hierarchia*, PL 122:1037–70.

Pseudo-Dionysius, *De Ecclesiastica Hierarchia*: Dionysius, the Pseudo-Areopagite, *De Ecclesiastica Hierarchia*, PL 122:1071–1112.

Responsio Abbatum: *Responsio Abbatum (Suessione, 1132) Auctore Willelmo Abbate Sancti Theoderici*, ed. S. Ceglar, "Guillaume de Saint-Thierry et son rôle directeur aux premiers chapitres des abbés Bénédictins: Reims 1131 and Soissons 1132," *Saint-Thierry: une abbaye du VIe au XXe siècle*, Actes du Colloque international d'Histoire monastique (Saint-Thierry, 1979), 334–50.

Riposte: *Riposte*, ed. A. Wilmart, "Une riposte de l'ancien monachisme au manifeste de saint Bernard," *Revue Bénédictine* 46 (1934): 309–44.

Statuta: *Statuta Capitulorum Generalium Ordinis Cisterciensis*, ed. Joseph-Marie Canivez (Louvain, 1933).

Suger, *Ord, De Cons, De Adm*: Suger, *Ordinatio, De Consecratione, De Administratione*, ed. Erwin Panofsky, *Abbot Suger: On the Abbey Church of St-Denis and Its Art Treasures*, 2d ed. (Princeton, 1979).

Suger, ed. Lecoy: Suger, *Oeuvres complètes de Suger*, ed. Albert Lecoy de la Marche (Paris, 1867).

Suger, *Vie de Louis VI*: Suger, *Vie de Louis VI le Gros*, ed. and trans. H. Waquet, Les classiques de l'histoire de France au moyen âge 11 (Paris, 1929).

Vita Prima: *Sancti Bernardi Vita Prima*, PL 185:225–466.

William of St-Denis, *Dialogus*: William of St-Denis, "Le dialogue apologè-
tique du moine Guillaume, biographe de Suger," ed. A. Wilmart, *Re-
vue Mabillion* 32 (1942): 80–118.

William of St-Denis, *Vita Sugerii*: William of St-Denis, *Vita Sugerii*, PL
186:1193–1208.

SECONDARY LITERATURE

Baron 1957: Roger Baron, *Science et sagesse chez Hugues de Saint-Victor*
(Paris, 1957).

Bautier 1981: Robert-Henri Bautier, "Paris au temps d'Abélard," *Abélard
en son temps*, Acts du Colloque international organisé à l'occasion du
9e centenaire de la naissance de Pierre Abélard (Paris, 1981), 21–77.

Bernhardt 1987: John W. Bernhardt, "Servitium Regis and Monastic Prop-
erty in Early Medieval Germany," *Viator* 18 (1987): 53–87.

Blum 1986: Pamela Z. Blum, "The Lateral Portals of the West Facade of
the Abbey Church of Saint-Denis," in Gerson 1986b:199–227.

Bonnard 1904: F. Bonnard, *Histoire de l'abbaye royale et de l'ordre des cha-
noines réguliers de St-Victor de Paris* (Paris, 1904).

Bony 1983: Jean Bony, *French Gothic Architecture of the 12th and 13th Centu-
ries* (Berkeley, 1983).

Bony 1986: Jean Bony, "What Possible Sources for the Chevet of Saint-
Denis?" in Gerson 1986b:131–44.

Cartellieri 1898: Otto Cartellieri, *Abt Suger von Saint-Denis: 1081–1151* (Lü-
beck, 1898).

Chenu 1957: Marie-Dominique Chenu, *Nature, Man, and Society in the
Twelfth Century* (Chicago, 1957).

Christe 1966: Yves Christe, "A propos de l'*Apologia* de saint Bernard: Dans
quelle mesure Suger a-t-il tenu compte de la réforme cistercienne?"
Genava n.s. 14 (1966): 5–11.

Constable 1986: Giles Constable, "Suger's Monastic Administration," in
Gerson 1986b:17–32.

Crosby 1942: Sumner McKnight Crosby, *The Abbey of St-Denis: 475–1122*
(New Haven, 1942).

Crosby and Blum 1973: Sumner McKnight Crosby and Pamela Z. Blum,
"Le Portail central de la façade occidentale de Saint-Denis," *Bulletin
Monumental* 131 (1973): 209–66.

Crosby 1987: Sumner McKnight Crosby, ed. and completed by Pamela Z.
Blum, *The Royal Abbey of St-Denis: From Its Beginnings to the Death of
Suger, 475–1151* (New Haven, 1987).

Ehlers 1973: Joachim Ehlers, *Hugo von St Viktor: Studien zum Geschichtsdenken und zur Geschichtsschreibung des 12. Jahrhunderts* (Wiesbaden, 1973).

Félibien 1706: Michel Félibien, *Histoire de l'abbaye royale de Saint-Denys en France* (Paris, 1706; reprint Paris, 1973).

Gardner 1984: Stephen Gardner, "Two Campaigns in Suger's Western Block at St-Denis," *Art Bulletin* 66 (1984): 574–87.

Gerson 1970: Paula Lieber Gerson, "The West Facade of St-Denis: An Iconographic Study," Ph.D. diss. (Columbia University, 1970).

Gerson 1986a: Paula Lieber Gerson, "Suger as Iconographer: The Central Portal of the West Facade of Saint-Denis," in Gerson 1986b:183–98.

Gerson 1986b: ed. Paula Lieber Gerson, *Abbot Suger and Saint-Denis: A Symposium* (New York, 1986).

Glaser 1965: Hubert Glaser, "Wilhelm von Saint-Denis: Ein Humanist aus der Umgebung des Abtes Suger und die Krise seiner Abtei von 1151 bis 1153," *Historisches Jahrbuch* 85 (1965): 257–322.

Grodecki 1961: Louis Grodecki, "Les vitraux allégoriques de Saint-Denis," *Art de France* 1 (1961): 19–46.

Hauréau 1886: J. B. Hauréau, *Les Oeuvres de Hugues de Saint-Victor* (Paris, 1886).

Kidson 1987: Peter Kidson, "Panofsky, Suger and St Denis," *Journal of the Warburg and Courtauld Institutes* 50 (1987): 1–17.

Kimpel and Suckale 1985: Dieter Kimpel and Robert Suckale, *Die gotische Architektur in Frankreich 1130–1270* (Munich, 1985).

Leclercq 1961: Jean Leclercq, *The Love of Learning and the Desire for God: A Study of Monastic Culture* (New York, 1961).

Lecoy: ed. Albert Lecoy de la Marche, *Oeuvres complètes de Suger* (Paris, 1867).

de Lubac 1959: Henri de Lubac, *Exégèse médiévale: Les quatre sens de l'écriture* (Paris, 1959–1964).

Panofsky 1979: Erwin Panofsky, *Abbot Suger: On the Abbey Church of St-Denis and Its Art Treasures*, 2d ed. (Princeton, 1979).

Rorem 1984: Paul Rorem, *Biblical and Liturgical Symbols within the Pseudo-Dionysian Synthesis*, Pontifical Institute of Mediaeval Studies: Studies and Texts 71 (Toronto, 1984).

Rudolph 1987: Conrad Rudolph, "The 'Principal Founders' and the Early Artistic Legislation of Cîteaux," *Studies in Cistercian Art and Architecture* 3, Cistercian Studies Series 89 (Kalamazoo, Mich., 1987), 1–45.

Rudolph 1991: Conrad Rudolph, *The Things of Greater Importance: Bernard of Clairvaux's Apologia and the Medieval Attitude toward Art* (Philadelphia, 1991—projected).

von Simson 1974: Otto von Simson, *The Gothic Cathedral: Origins of Gothic Architecture and the Medieval Concept of Order*, 2d ed. (Princeton, 1974).

von Simson 1988: Otto von Simson, retrospective review of von Simson, *The Gothic Cathedral: Origins of Gothic Architecture and the Medieval Concept of Order*, in the *Frankfurter Allgemeine Zeitung*, January 27, 1988, 35–36.

Smalley 1952: Beryl Smalley, *The Study of the Bible in the Middle Ages* (New York, 1952).

Spicq 1944: Ceslas Spicq, *Esquisse d'une histoire de l'exégèse latine* (Paris, 1944).

Vacandard 1902: Elphège Vacandard, *Vie de saint Bernard*, 3d ed. (Paris, 1902).

Van den Eynde 1960: Damien Van den Eynde, *Essai sur la succession et la date des écrits de Hugues de Saint-Victor*, Spicilegium Pontificii Athenaei Antoniani 13 (Rome, 1960).

Verdier 1986: Philippe Verdier, "Some New Readings of Suger's Writings," in Gerson 1986b:159–62.

Wailes 1985: Stephen L. Wailes, "Why Did Jesus Use Parables? The Medieval Discussion," *Medievalia et Humanistica* n.s. 13 (1985): 43–64.

Warnke 1979: Martin Warnke, *Bau und Uberbau: Sociologie der mittelalterlichen Architektur nach den Schriftquellen*, 2d ed. (Frankfurt a.M., 1979).

Zinn 1972: Grover A. Zinn, "Mandala Symbolism and Use in the Mysticism of Hugh of St Victor," *History of Religions* 12 (1972–1973): 317–41.

Zinn 1975: Grover A. Zinn, "*De Gradibus Ascensionum*: The Stages of Contemplative Ascent in Two Treatises on Noah's Ark by Hugh of St Victor," *Studies in Medieval Culture* 5 (1975): 61–79.

Zinn 1986: Grover A. Zinn, "Suger, Theology, and the Pseudo-Dionysian Tradition," in Gerson 1986b: 33–40.

INDEX

PRINCETON ESSAYS ON THE ARTS

Guy Sircello, *A New Theory of Beauty* (1975)

Rab Hatfield, *Botticelli's Uffizi "Adoration": A Study in Pictorial Content* (1976)

Rensselaer W. Lee, *Names on Trees: Ariosto Into Art* (1976)

Alfred Brendel, *Musical Thoughts and Afterthoughts* (1977)

Robert Fagles, *I, Vincent: Poems from the Pictures of Van Gogh* (1978)

Jonathan Brown, *Images and Ideas in Seventeenth-Century Spanish Painting* (1978)

Walter Cahn, *Masterpieces: Chapters on the History of an Idea* (1979)

Roger Scruton, *The Aesthetics of Architecture* (1980)

Peter Kivy, *The Corded Shell: Reflections on Musical Expression* (1980)

James H. Rubin, *Realism and Social Vision in Courbet and Proudhon* (1981)

Mary Ann Caws, *The Eye in the Text: Essays on Perception, Mannerist to Modern* (1981)

Morris Eaves, *William Blake's Theory of Art* (1982)

E. Haverkamp-Begemann, *Rembrandt: The Nightwatch* (1982)

John V. Fleming, *From Bonaventure to Bellini: An Essay in Franciscan Exegesis* (1982)

Peter Kivy, *Sound and Semblance: Reflections on Musical Representation* (1984)

John N. King, *Tudor Royal Iconography: Liteature and Art in an Age of Religious Crisis* (1989)

Conrad Rudolph, *Artistic Change at St-Denis: Abbot Suger's Program and the Early Twelfth-Century Controversy over Art* (1990)

ILLUSTRATIONS

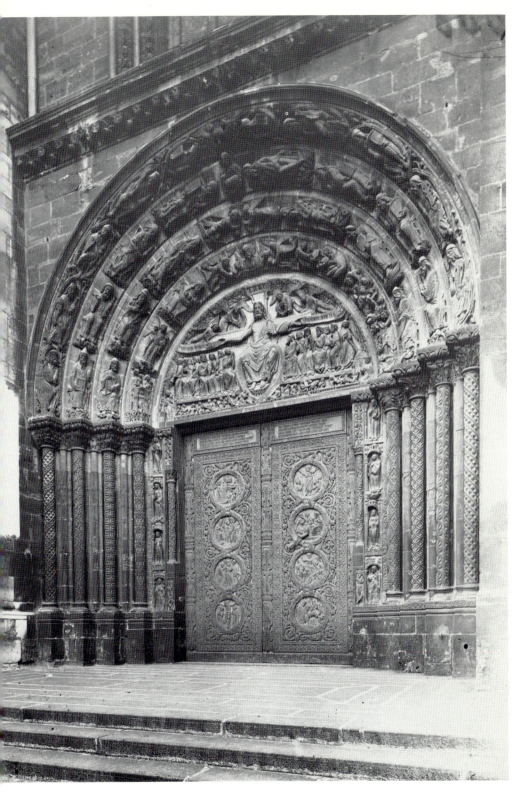

1 St-Denis, west central portal.

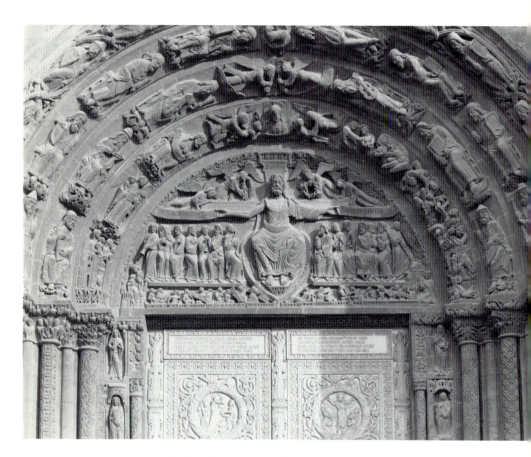

2 St-Denis, west central portal, tympanum.

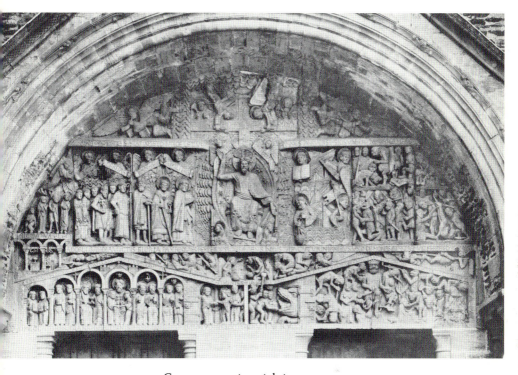

3 Conques, west portal, tympanum.

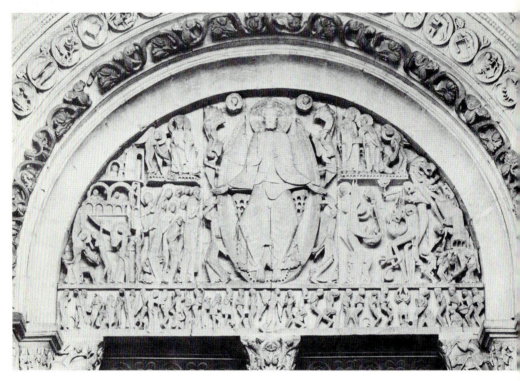

4 Autun, west central portal, tympanum.

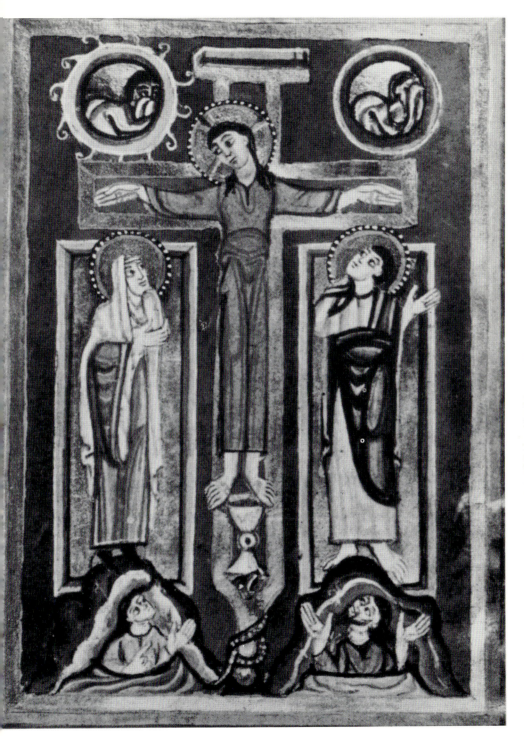

5 *Crucifixion*, Gospels, Echternach.
London, British Library, Egerton *ms* 608, fol. 88.

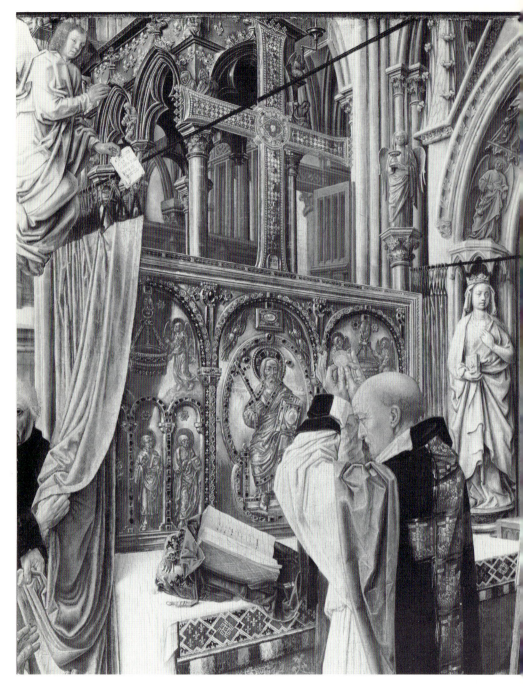

6 The Cross of St Eloi and the Antependium of Charles the Bald.
Master of St Giles, *The Mass of St Giles*. London, National Gallery.

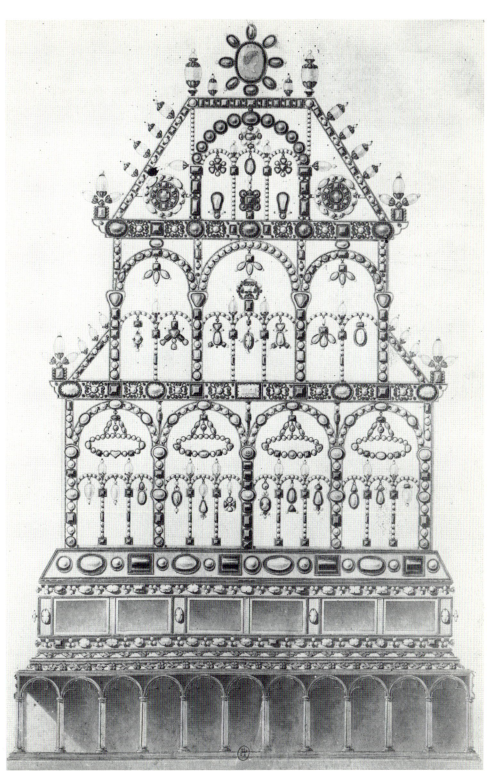

7 The Crest of Charlemagne, drawing.
Paris, Bibliothèque nationale.

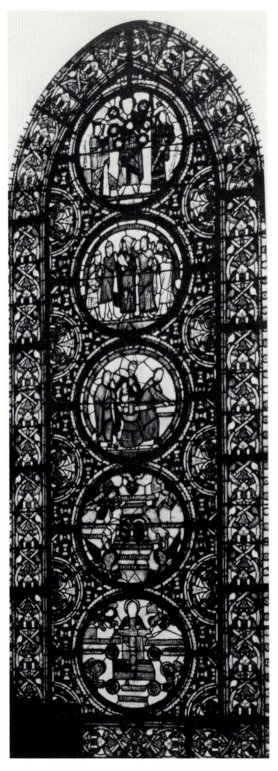

8 St-Denis, Allegorical Window in its present, altered state. The Mystic
Mill panel (which is now in the center and is not original) was probably
originally the lowest panel.

9 Vézelay, Mystic Mill capital; contemporary with Suger's abbacy.

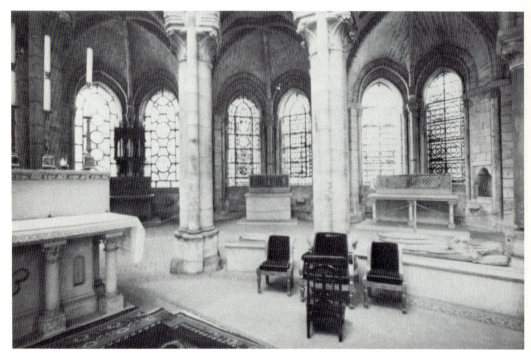

10 St-Denis, ambulatory.

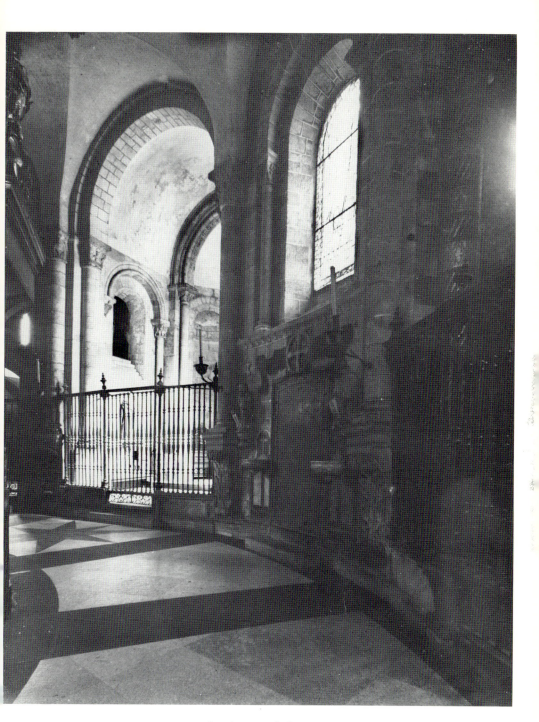

11 Santiago, ambulatory.

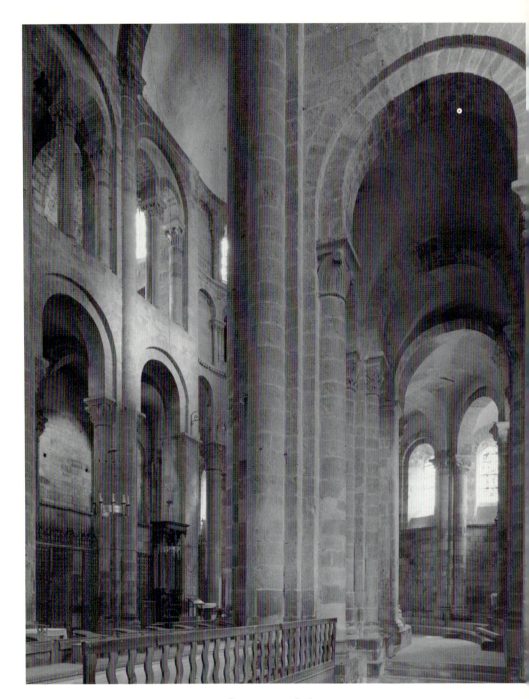

12 Conques, ambulatory.

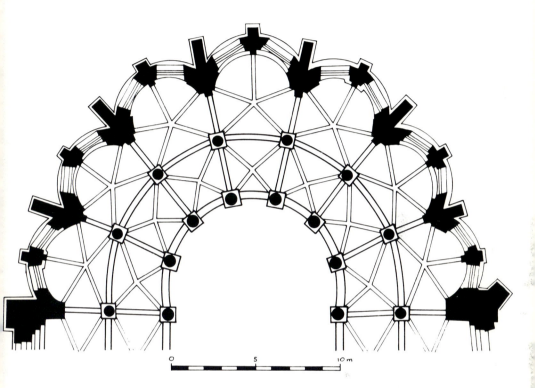

13 St-Denis, ambulatory plan.

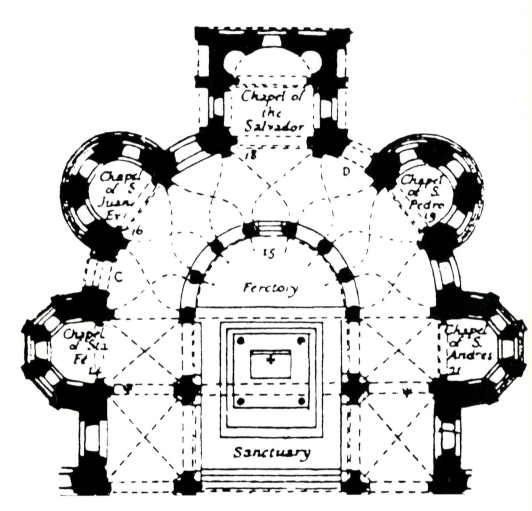

14 Santiago, ambulatory plan.